THE MISSING PEACE

Artists & the Dalai Lama

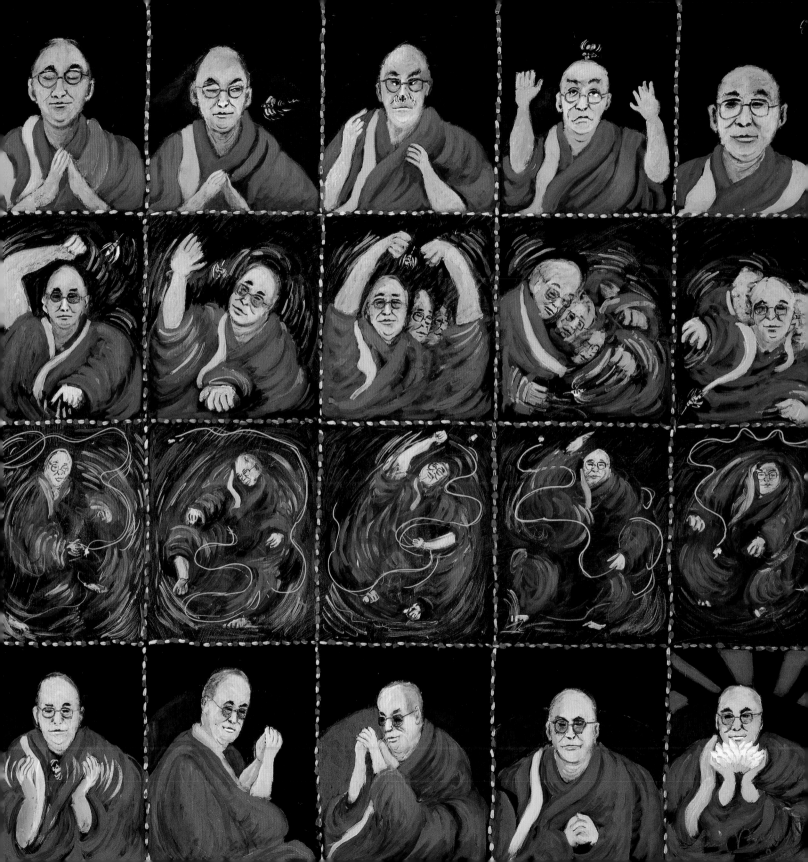

THE MISSING PEACE
Artists & the Dalai Lama

COMMITTEE OF 100 FOR TIBET
& THE DALAI LAMA FOUNDATION

Curated by Randy Jayne Rosenberg

EARTH AWARE
San Rafael, California

Betlach Family FOUNDATION

Thanks to the Betlach Family Foundation for their generous support.

EARTH AWARE

Earth Aware Editions
17 Paul Drive
San Rafael, CA 94903

415.526.1370

www.earthawareeditions.com

Library of Congress Cataloging-in-Publication Data available.

ISBN: 1-932771-92-1

Palace Press International, in association with Global ReLeaf, will plant two trees for each
tree used in the manufacturing of this book. Global ReLeaf is an international campaign
by American Forests, the nation's oldest nonprofit conservation organization and a world
leader in planting trees for environmental restoration.

10 9 8 7 6 5 4 3 2 1

Cover image © 2005 *Reincarnation* by Salustiano

Table of Contents

preface H.H. THE DALAI LAMA *vi*

curator's notes RANDY ROSENBERG *viii*

1 interpreted portraits 2
Kasur Tenzin N. Tethong:
 Walking with the Dalai Lama 4

2 Tibet 18
Joel Makower:
 The Dalai Lama and the Rivers of Tibet 20

3 beliefs 30
Professor Robert A. Thurman: *Tibetan Buddhism* 32

4 empathy and compassion 46
Noa Jones: *Meditation on Creativiy* 48
John Geirland: *Buddha on the Brain* 50

5 transformation 62
Laurie Anderson: *From the Air* 64

6 humanity in transition 80
Pico Iyer: *Messenger from a Burning House* 82
Archbishop Desmond Tutu: *Truth and Reconciliation* 84

7 the path to peace 98
Arun Gandhi: *Nonviolence: The Only Hope* 100

8 unity 114
Jeff Greenwald: *Do Aliens Have a Buddha Nature?* 116
John Perkins: *The Dalai Lama, Indigenous Shamans,
 Art and Unity of All Things* 120

9 spirituality and globalization 134
Lilly Wei: *Only Connect* 136

10 impermanence 148
David & Hi-Jin Hodge:
 Quotations from Video Interviews 150

Afterword 160
Darlene Markovich, President of the Committee of 100
for Tibet, Executive Director, *The Missing Peace Project*

biographies 162

acknowledgments 170

colophon 172

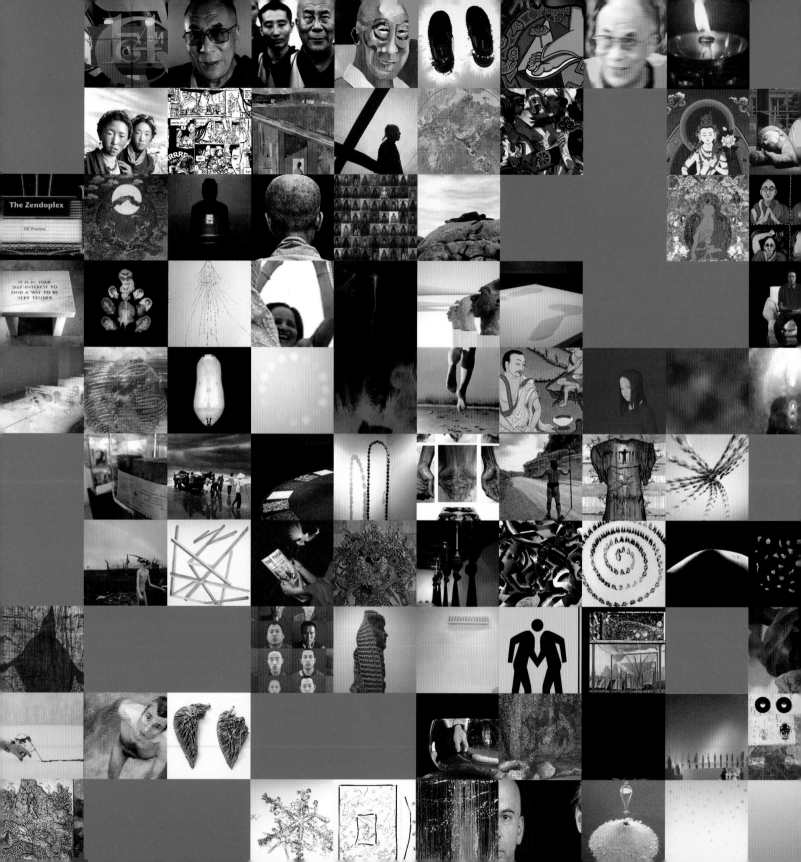

Preface

I AM HAPPY AND HONORED to see that this project is now complete, not because I want people to know more about me personally, but because it draws attention to a cause I hold dear, the achievement of genuine lasting world peace. At the same time, the project itself demonstrates that individuals working together on many fronts are the best way to advance towards our goals.

This project is not focused on the work of individual artists, but upon peace. These works of art collectively seek to create zones of peace, and are intended to inspire others to generate compassion, love and patience, which are essential if human beings are to achieve happiness.

Art has an important communicative and inspirational role to play in our lives. In my own land of Tibet, for example, we had rich traditions of using art to remind us of the goals we sought. We also used art to create an atmosphere conducive to the achievement of those goals. I have no doubt about art's power to inspire.

I hope that the messages reflected in these works will not go unheeded. All human beings carry the potential for peace within them, but we have to work to develop it. The works in this exhibition can serve as an inspiration for people to cultivate peace and harmony in their own lives. This is important because I believe we can transform ourselves and the societies to which we belong. I am convinced that if more of us could spend a few minutes every day trying to develop a sense of inner peace, eventually it would become part of our lives; then everything we do will contribute to peace in the world.

H.H. The Dalai Lama

June 15, 2006

Curator's Notes

How does an artist consider the Dalai Lama? Not the man, whose gentle but powerful visage is widely recognized, but his imprint on the world: his vision, ideals, values, and teachings. How do you portray them in a visual medium?

That question began a journey that has resulted in this exhibition, in which eighty-two artists and artist collaboratives from twenty-five countries have created their own answers. These artists have tapped into their unique belief systems and perspectives to create visual portraits of how they perceive the Dalai Lama. The result is a collective tapestry of images, themes, and media that mirror the many roles His Holiness plays within his world and ours: statesman, philosopher, politician, holy man, visionary, peacemaker, icon, and more.

In early 2004, when I was invited by the Dalai Lama Foundation and the Committee of 100 for Tibet, the two sponsoring organizations, to curate this exhibition, I knew little about Buddhism and the Tibetan plight. But I understood well the overarching vision: to portray His Holiness on a broader and a more universal platform. And thus began the exploration: Who is the Dalai Lama and what universal themes do his life and work embody?

The answers are many. He is a beloved global spiritual leader, a political leader, and a Buddhist. He is a head of state in exile, a political refugee who has demonstrated a path to peace through compassion, empathy, and responsible living. He is a man who respects all life equally. He is also a man who generates a wonderfully contagious laugh and a capacity for great happiness in spite of life's obstacles.

The art critic Robert Morgan once described the driving force of a particular artist's work as the desire to obtain meaning as a necessary fulfillment of life. No description could better inform this project. In the quest to translate the Dalai Lama's diverse qualities into visual media, the search for meaning and identity become inextricably bound to each other.

My journey led me to discuss the Dalai Lama with artists from around the world. Many of them I knew from my years curating the art collections of the World Bank, the International Finance Corporation, and the Carnegie Endowment for International Peace. Curators worldwide enthusiastically contributed names of other artists for possible inclusion.

The list quickly grew. The artists selected were those whose works resonated with the great themes and ideals the Dalai Lama expresses: the power of spirituality, the mystery of transcendence, universal interconnectedness, the importance of human dignity, the need for peace. Each of the artists selected intuitively understood his or her unique role in the exhibition.

The artists were asked to donate their artworks to support the continuing peace initiatives of the two sponsoring organizations. They responded generously to this request by creating a breadth and quality of new and substantial work that is museum-worthy. As the new works emerged, it became clear that this exhibition is less the story of one man's life and more the artists' stories as they reflect their shared ideals, personified by the Dalai Lama.

The themes that emerged became the organizing principle of the show. The exhibition can be seen as a spiral, beginning with the more concrete concepts about the Dalai Lama: his appearance, beliefs, religion, and homeland. The show then circles outward to include increasingly more abstract and universal themes: the ideals of human rights, peace, and compassion; people in exile; an exploration of belief systems; paths of transformation; universal responsibility; globalization; and ideas of temporality and impermanence.

One of the central roles of art and the artist is to encourage us to think about the forces that shape our lives. The transformative power of art invites us to reflect on our beliefs about those forces, and to make the shifts in our perceptions necessary to expand them. That is also the purpose of each of the works in this exhibition: to educate, inspire, transform, engage, and heal.

Each of these artists brings a unique set of ideas and experiences to this exhibition, tapping not just their artistic output but also their artistic process to engage us. Their stories, expressed through the art they created for this exhibition, intersect with, explore, and elaborate on the themes of the show.

For example, Palestinian artist Tayseer Barakat, born in a refugee camp in Gaza, creates images using burned materials that suggest the cataclysm of the expulsion of his family from their homeland. Like the Dalai Lama, who has been in exile from Tibet since 1959, Barakat struggles with issues of displacement.

In his epic work for this exhibition, *A Brief History of Tibet*, the Tibetan artist Tenzing Rigdol evokes a reaction similar to emotions inspired by Picasso's painting, *Guernica*, engulfing the viewer psychologically in the bold visual antiwar statement.

The tapestry by Nigerian artist El Anatsui stands as a reminder of temporality and decay. Thousands of discarded bottle caps are sewn with copper wire into a monumental cloth hanging. Anatsui weaves the debris of consumerism into a glittering textile in the long tradition of West African textile production, prompting us to reexamine what makes up the very fabric of our lives.

Adam Fuss contributed his photograph *White Chrysalis*. The membranes of the pods invite us to linger over the caterpillar and, in the moment, recognize the transformative power of the crawler as it evolves into a luscious flying creature.

The idea that we are all part of a greater community is reflected in the work of video artist Bill Viola. Viola and his family visited the Dalai Lama in Dharamsala, where he filmed His Holiness delivering prayers and blessings. Viola transformed this footage into a video portrait. His intent is that we can all be recipients of these blessings, a gesture to be received and shared by all the thousands of visitors to this exhibition.

For Susan Plum's performance/installation on the missing women of Juarez, Mexico, the healing process is an integral part of her art. Plum sees the Rio Grande at the Texas–Mexico border as an open wound and her art as a shamanic opportunity to bring awareness and healing, or *limpia*.

Juan Galdeano of Spain created a bubble machine installation. Titled *The Perfect Moment*, the work asks us to share in a communal dream in which we can perceive the infinite, seek enlightenment, and create art that transforms the arbitrary nature of beauty into a beauty with purpose.

There are more than seventy other stories revealed in the exhibition—all worthy of our attention.

Early on in this project, Tenzin Tethong, former cabinet member to the Tibetan Government in Exile, stated that the goal of the exhibition is not one of hero worship or political rhetoric. It is not about the fight for Tibetan freedom. And it is not how we can become the Dalai Lama, or walk in his footsteps.

Rather, the exhibition shows how we can walk alongside the Dalai Lama—each of us with our own story—and how our stories can interweave with his story, all the stories together becoming a new story of human consciousness.

RANDY JAYNE ROSENBERG
Curator
Oakland, California

INTERPRETED PORTRAITS

ARTISTS:

Richard Avedon

Ken Aptekar

Chuck Close

Chase Bailey

Sylvie Fleury

Losang Gyatso

Robin Garthwait & Dan Griffin

Bill Viola

"Spend some time alone every day."

—The Dalai Lama

THE DALAI LAMA represents many things to many people. To those who study and practice with him, he is a spiritual companion, a teacher, a pathway to liberation. To the Norwegian Nobel Committee, he is a laureate, a forward-thinking advocate of peace. To the Tibetan Government in Exile (and those who recognize it), he is a head of state. To some governments, he is a dissident and a threat. To a number of neuroscientists, he is a collaborator. To the thousands of refugees who rely on his support, he is a patron. To the modern world, he is an icon, an author, an activist, and a philosopher.

Born to a simple peasant family in 1935, he was named Lhamo Thondup. Two years later, upon being recognized as the Fourteenth incarnation of the Dalai Lama lineage of Tibetan Buddhism, he was renamed Jetsun Jamphel Ngawang Lobsang Yeshe Tenzin Gyatso (Holy Lord, Gentle Glory, Compassionate, Defender of the Faith, Ocean of Wisdom). Many refer to him simply as Kundun—the Presence. And while traditional Buddhist practitioners are devoted to him as the embodiment of enlightened compassion and a manifestation of all Buddhas, he appears to many as an ordinary man speaking of extraordinarily simple concepts that can change the world.

Kasur Tenzin N. Tethong

walking with
the dalai lama

T O ALL WHO HAVE CHOSEN to participate in one way or another in The Missing Peace Project, I say that you have chosen to walk with His Holiness the Dalai Lama.

Whenever an extraordinary person appears in our midst, often in trying and challenging times, the vast majority of us fail to appreciate the full worth of such individuals, and belatedly memorialize and mythologize their lives and their work when they are no longer with us. I say we can do better, and I say that we should walk with the Dalai Lama today; walk with him on his journey of peace and hope, rather than trail in his footsteps in the future.

I invite each of you to join in this "walk," and by sharing with you my brief summation of the Dalai Lama's extraordinary life, the highs and lows, and the significance of it all, I hope that you might understand why we should cherish this opportunity.

Since His Holiness is an immensely revered and beloved figure, it is not easy to write about him in a casual manner, especially for a Tibetan. No matter what one writes, it may never satisfy those who see him as more than an ordinary being. Even on a conventional level he is not just a leader since he is both temporal and spiritual guide of a people and a nation. And for the devout, he is the manifestation of the Bodhisattva of Compassion, the embodiment of the compassion of all the Buddhas, or as some might say, the essence of compassion in the universe.

To simply tell his life story is not difficult, because it is filled with so many extraordinary events. It begins with his recognition as the reincarnation of the Thirteenth Dalai Lama of Tibet, and is followed by great drama and tragedy early in his life, and later by unforeseen triumphs and successes.

Born on July 6, 1935, to a farming family in the small village of Taktser in northeastern Tibet, he is named Lhamo Thondup. When he is barely able to speak, he utters words in a dialect from distant Lhasa stating that he needs to go there. When members of the official search party come looking for the reincarnation of the Thirteenth Dalai Lama, he recognizes the monk who is disguised in layman's clothes. Later, when tested, he flawlessly chooses the objects belonging to the previous Dalai Lama that are laid alongside similar items, some more elaborate and attractive to any child. These stories and more have been written and told by members of the search party, distinguished lamas and senior officials of Tibet, and by members of own his family. All are now part of the lore and myth of the present Dalai Lama.

Once recognized, he is taken to Lhasa, but only after the Tibetan government purchases safe passage from the Chinese Muslim warlord Ma Bufang, a man holding considerable sway in the region who threatens to hold him back. Successfully escorted to the Tibetan capital, the young Dalai Lama—now given a much longer new name, Jetsun Jamphel Ngawang Lobsang Yeshe Tenzin Gyatso, or Holy Lord, Gentle Glory, Compassionate, Defender of the Faith, Ocean of Wisdom, the short form of which is Tenzin Gyatso—is officially enthroned in 1940.

In Lhasa he begins a life confined mainly to his spiritual education, and is visited only occasionally by family members. Gradually he is exposed to the intricacies and politics of governance. But this traditional preparation of a future leader is cut short in 1950, when Tibet is invaded by China. Barely sixteen years of age, he is rushed to take on the role of head of state. Although Chinese troops are already in the country, the entire Tibetan nation turns to him believing that he will avert the national crisis, when in fact it has already unfolded.

The young Dalai Lama assumes the role thrust on him without hesitation. He begins to introduce reforms within the Tibetan polity and he starts to engage with the Chinese. In 1954, when he is invited to China, he goes straight to the Chinese authorities and forthrightly attempts to work with them. Just as modern socialist China impresses the Dalai Lama, he too impresses Mao and others with the great potential they see in him and the Tibetan people.

After his return from China, he travels to India in 1956 as a special guest to commemorate the 2,500th year of Buddhism. He sees India as another Asian giant embarking on a similar journey of modern nation building, but one which, in contrast to China, is committed to greater human freedoms and democracy, and in which spirituality and the ancient cultures still seem to have a place.

Thus exposed to China and India, the young Dalai Lama is thrust into the modern world with all its promises and potential. But the clash between Chinese Communism and traditional Tibetan beliefs stands in his way. No matter how eager the young Dalai Lama is to move ahead and work out the differences with the Chinese, Tibetan ideas of race, religion, and society cannot be reconciled with those of international communism.

These fundamental differences are compounded by the Chinese haste for "reform" and by their lack of basic respect for the Tibetan people and their views. Despite assurances given by Chairman Mao, Chinese officials in Tibet become less flexible and push aggressively with their revolutionary reforms, especially in eastern Tibet. Such actions lead to the beginning of skirmishes in many parts of the country and the outbreak of the first major clash in Lithang in 1957. The Tibetan uprising is swiftly and brutally put down by Chinese forces and the monastery of Lithang, the center of resistance, is completely destroyed.

Greater resentment and fear of the Chinese quickly spread throughout Tibet. Soon Lhasa is filled with refugees, and public demonstrations against the Chinese become commonplace. The Dalai Lama urges patience and cooperation and counsels against the use of violence, but the situation does not improve. While he remains the great symbol of hope, he also becomes the center around which all the fears and passions of the Tibetan people swirl. The disastrous conclusion of this clash between the Tibetans and the Chinese seems inevitable.

Finally, when the Chinese drop their veiled pretense at diplomacy and insist that the Dalai Lama visit them in their military camp, without his usual and proper escort, their intentions become clear. When word gets out, thousands of Tibetans immediately swarm to his summer palace, Norbulingkha, to protect him and to prevent him from being taken by force. The crowds are volatile and unpredictable; their worst fears and resentments of the Chinese surface in outbursts of mob violence, resulting in the death of a Tibetan known to be close to the Chinese as well as in the accidental stoning of a Tibetan minister. There are no options left for the Dalai Lama but to remove himself from the center of this storm if he is to prevent bloodshed and if there is to be a future to strive for. On March 17, 1959, the Dalai Lama slips out of the palace in the middle of the night, disguised as a soldier on a change of guard duty. He escapes and begins the most important journey of his life, not knowing where he is headed or where his journey will end.

The Dalai Lama is not alone on this journey; he is accompanied by his mother and his younger brother, and is escorted by government officials and soldiers, as well as the Chushi Gandruk, the underground resistance. The party heads south from Lhasa. In the few first days, they pass through territories under firm Tibetan control. With no assurances of evading Chinese pursuit, the escape party finally heads towards India. Twenty four days later, exhausted and recovering from an illness, the Dalai Lama reaches the Indian border, welcomed by a cable from the Indian Prime Minister and by the world press, which is eager to report on one of the great escape stories of all time.

With the beginning of his exile, the Dalai Lama's world and that of the Tibetan people—Tibetan polity and Tibetan society as it has developed from the time of the early kings of Tibet nearly two thousand years ago—comes to a dramatic end. The Tibetan uprising is completely crushed within the next few months. With only limited protest from the outside world, China begins the process of transforming Tibet into its mold.

The Dalai Lama is no longer a monarch but a simple refugee in India, without his court, without his country, and without his people. His future and that of the Tibetan people hang precariously. It is a time of great trial for all Tibetans, including the majority under Chinese rule and the small band that had followed him into exile. It is a test as challenging as survival on the Tibetan plateau, and as complex as the centuries-long pursuit of personal and universal liberation.

As a refugee and a survivor he has to lead his people out from the depths of despair. Together with the exiled leadership, he rebuilds the communities, takes care of the young and the old, revives key traditions and institutions of Tibet's cultural heritage, and prepares the next generation for a future Tibet that will be free and democratic.

What the Dalai Lama and the exiles have achieved is extraordinary, not only in rebuilding their lives and communities but in saving the essence of Tibet's rich cultural heritage, and moreover, in establishing its value and relevance both within the community and beyond. These are no minor achievements. They have been accomplished in the face of great suffering of the Tibetan people and the tremendous physical destruction in their homeland. Instead of dwelling on the past, the exiles have pulled themselves up, primarily on their own, with only meager resources at their disposal. Today, a Tibetan may be an exile anywhere in the world, or living under Chinese occupation, but she or he is a proud citizen of a virtual and global Tibetan nation, one far from the ideal but which exists nevertheless.

Even before he left Tibet at the age of twenty-five, the present Dalai Lama had already assumed a secular role for nearly a decade. In the midst of great political turmoil he successfully carried out his Buddhist studies and completed, with distinction, his doctoral Geshe examinations. The Fifth and Thirteenth Dalai Lamas are considered "Great" Dalai Lamas, a "greatness" sparingly assigned by the Tibetan people. While some Dalai Lamas were saintly figures, and several were scholars or mystics, and others were important political figures, only two have been given the special distinction of being "great." Because of what he has already done for the Tibetan people, it is certain that the present Fourteenth Dalai Lama will also be considered "great" in this historical sense. And it is possible that he will be regarded as the greatest of the Dalai Lamas.

The world now knows the Dalai Lama as a Nobel Laureate and a man of peace. Countless awards and recognitions have been bestowed on him. But many are unaware of his ideas and his work for peace, which extend far beyond his concerns for the Tibetan people and the preservation of Tibet's unique heritage. His suggestions on how to prevent global inequities and conflicts, his work to promote genuine understanding and sharing among different spiritual traditions, and his efforts to bridge the worlds of science and spirituality are examples of a simple and profound message that points to the future, and to the great potential we all have.

The Dalai Lama has a tremendous following of individuals all over the world who identify with him and support his work with projects such as educating refugee children and nuns; contributing to the rebuilding of communities, monasteries and health clinics, inside and outside Tibet; and trying to untangle the complicated web of politics, human rights, and law regarding Tibet and its future status.

This coming together of friends and students of the Dalai Lama has contributed immensely to the success of his work and that of the exiles. Clearly, there is still much that needs to be done. The Tibetan issue is far from resolved, despite the Dalai Lama's great willingness to negotiate and to compromise with the Chinese on the issues they fear the most. The Tibetan people living in terror under Chinese rule and those living in exile will need outside support well into the future.

Each person who finds an affinity with the Dalai Lama or his work, be it a connection to Tibetan culture, Tibetan Buddhism, or a more personal connection, she or he must now find a way to respond to his call to action for a better world. If the Dalai Lama has been helpful to us, then it is appropriate and timely that we listen and respond to his ideas. By putting aside our self-interest, we can elevate our connection to him to a higher level and join him on his journey of compassion.

Being a part of the Missing Peace Project, each in our own way, is a wonderful opportunity to work for and with this unusual man. And so I say again, let us walk. Let us walk with a robust man seventy years young, fully engaged and committed to a better world, and let us make this journey together. ❧

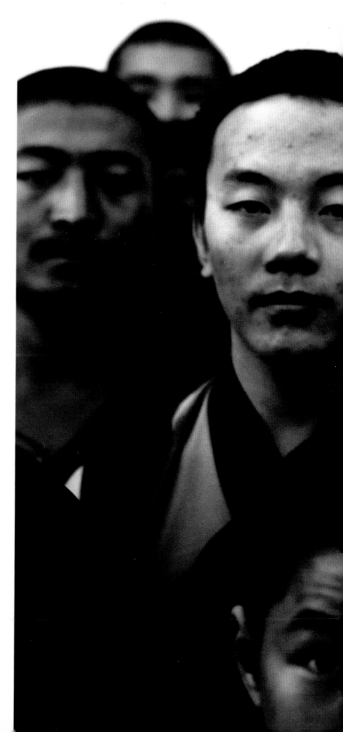

Richard Avedon

"A portrait photographer depends upon another person to complete his picture. The subject imagined, which in a sense is me, must be discovered in someone else willing to take part in a fiction he cannot possibly know about. My concerns are not his. We have separate ambitions for the image. His need to plead his case probably goes as deep as my need to plead mine, but the control is with me. A portrait is not a likeness. The moment an emotion or fact is transformed into a photograph it is no longer a fact but an opinion. There is no such thing as inaccuracy in a photograph. All photographs are accurate. None of them is the truth."

His Holiness the Dalai Lama and Monks (detail), 1998
Gelatin silver print
20 × 24 inches

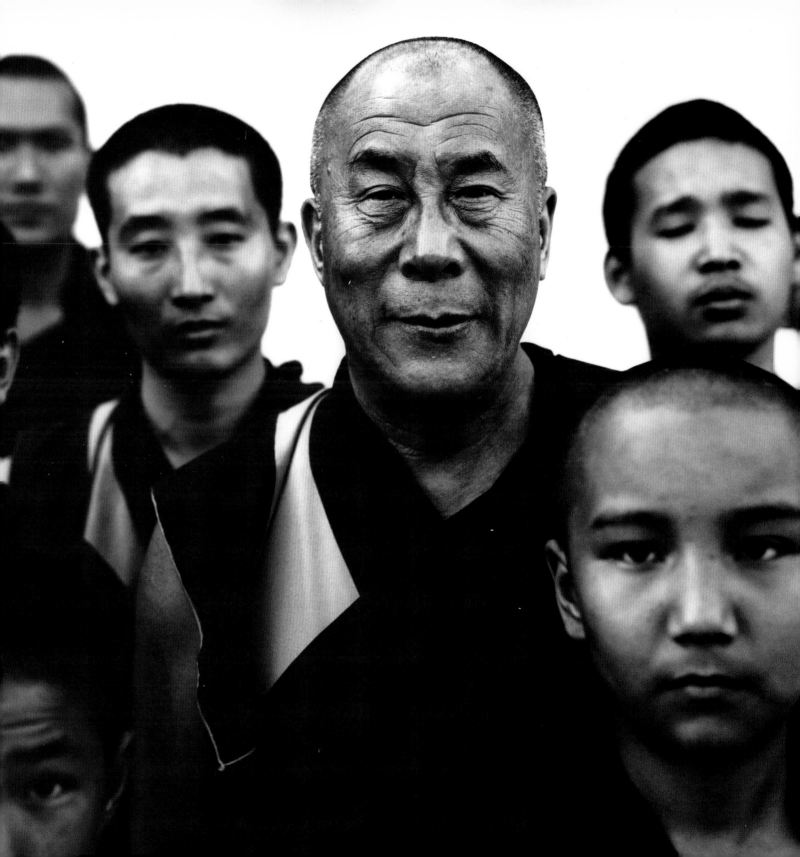

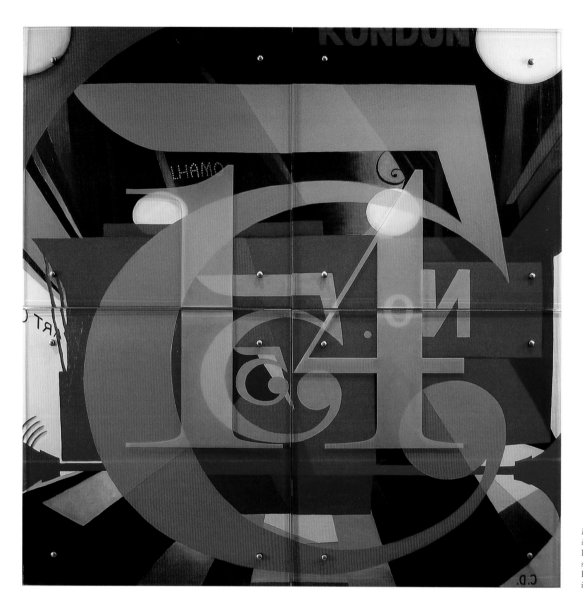

I Saw the Figure Five in Gold, 2005
Paint on wood with sandblasted glass overlay
Four panels, 60 × 60 inches each

Ken Aptekar

This portrait of the Dalai Lama is a kind of reincarnation itself of a painting by Charles Demuth titled, *The Great Figure* based on Demuth's friend, the poet Willliam Carlos Williams. Aptekar made some changes to Demuth's original painting, such as adding a large "14" sandblasted into the glass, referring to Lhamo Thondup's incarnation as the Fourteenth Dalai Lama; pushing the color into burgundy and saffron—colors associated with the Dalai Lama; and substituting "Kundun," the nickname for the Dalai Lama, for Demuth's original reference to "Carlos" and "Bill."

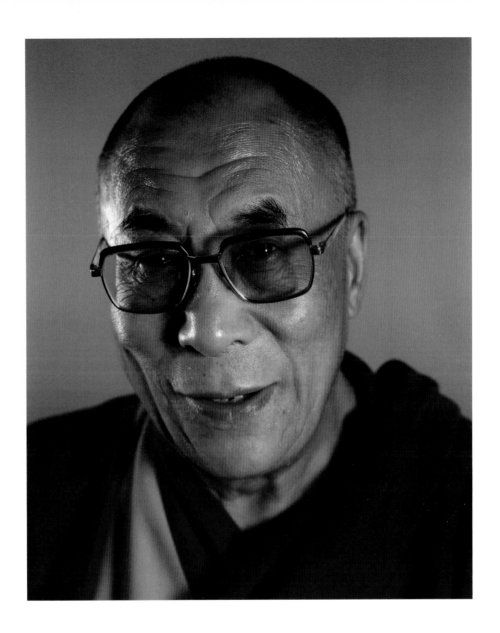

Chuck Close

Close is known for his large, iconic portraits such as this photograph of the Dalai Lama.
The artist achieved his international reputation by demonstrating that a very traditional genre,
portraiture, could be resurrected to become a challenging form of contemporary expression.

The Dalai Lama, 2005
Digital pigment print
50 × 40 inches

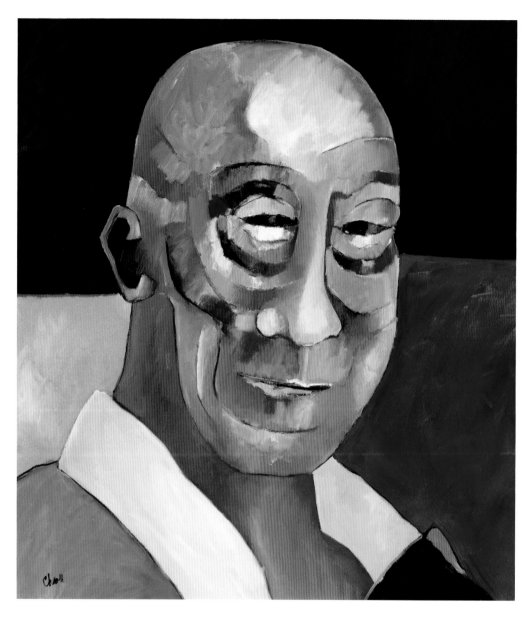

Evolution into a Manifestation
(Evolution vers une Incarnation), 2005
Oil on linen
59 × 53 inches

Chase Bailey

"My intention was to create in the viewer a meditative sense of the Dalai Lama, his reincarnation, and his evolutionary journey; I tried to communicate a feeling of his enduring evolution, and not simply present an image of his physical body. His aura is captured and expressed to give the viewer an experience of his inner strength, his peace, and to create an occasion of oneness with the wonderful and paradoxical sentient presence of infinite compassion."

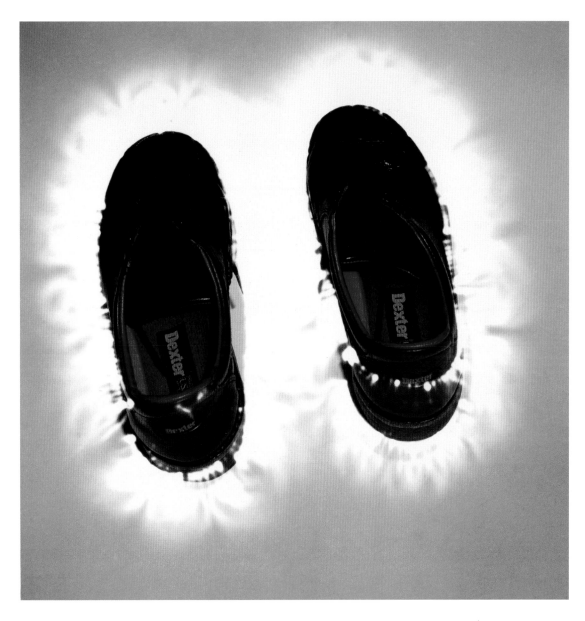

Sylvie Fleury

The Dalai Lama's Shoes, 2005
Kirlian photograph
40 × 40 inches

Fleury uses a process called Kirlian photography to portray the Dalai Lama's aura. By procuring an object that belonged to the Dalai Lama, Fleury tries to capture his energy field through his shoes.

In sharing the story with the Dalai Lama about his shoes for this exhibition, His Holiness chuckled and noted the shoes had been resoled several times, and that the resulting aura might well be that of his cobbler.

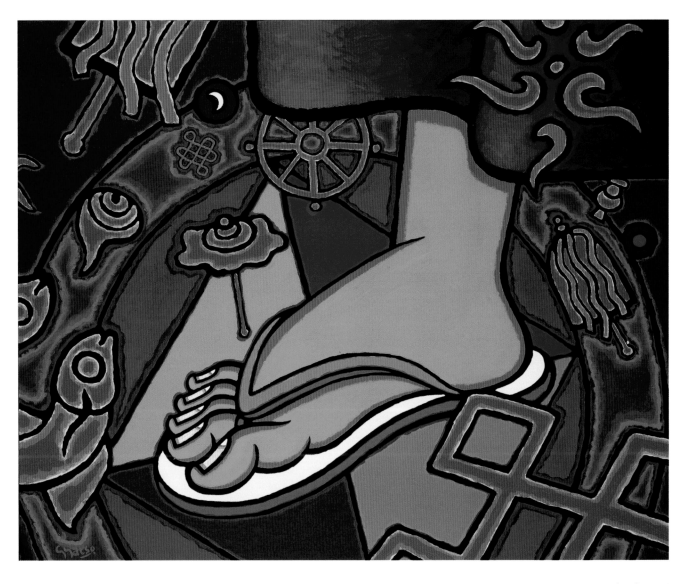

Losang Gyatso

Tenzin Gyatso, Ocean of Wisdom, 2005
Acrylic on canvas
30 × 36 inches

In 1940 at the age of five, the current Dalai Lama assumed the name Tenzin Gyatso, and he was officially proclaimed the Fourteenth Dalai Lama. "Dalai Lama" is a Mongolian name meaning "Ocean of Wisdom." Dalai Lamas are thought to be manifestations of the Bodhisattva of Compassion, and are called Chenrezig in Tibetan and Avalokiteshvara in Sanskrit.

Robin Garthwait & Dan Griffin

In the Moment, 2005
Video installation
3 minutes

"What is a moment with the Dalai Lama? Do we take the time to notice? It's a moment that is longed for, that can be unexpected. Can we hold on to that moment . . . hold it dear, recount its many facets, now and yet to be revealed?

Spend a moment and watch. Breathe it in. Feel it, taste it, even speak it to your mind. After all it's only a moment."

Bill Viola

Bill Viola and his family, Kira Perov and sons Blake and Andrei, visited with the Dalai Lama in Dharamsala, India, in late 2005. During that time, he videotaped His Holiness delivering this prayer. Viola shares this documentation with visitors entering this exhibition so that they, too, may receive a blessing from the Dalai Lama.

"The camera's open eye preserves short moments of nuns and monks in prayer to be circulated in far away lands, the DVDs spinning like tiny prayer wheels sending blessings in infinite repetition. Meanwhile, our hearts and minds receive all experiences in one long continuous stream of consciousness, linking all glimpses—the nine-hour train ride, the beggar with no legs, the woman with the blazing pink sari, the monkeys on the rooftops, the bright eyes of the young Buddhist nun, the old stone English church in the forest, the audience with His Holiness, the cyber café in Dharamsala, the transit lounge in Frankfurt airport—like knots on a single strand of thread, stations on a spiritual journey that will never end."

The Precious Bodhichitta*
If unborn, may it arise
If generated, may it never diminish
And may it remain ever-increasing
As long as space endures
And for as long as living beings remain
Until then may I too abide
To dispel the misery of the world
May all Motherly sentient beings be blissful and happy
May all the lower realms be permanently empty
And may all the Bodhisattvas** on whatever stage they remain
Fully accomplish all of their aspirations

TRANSLATION BY TASHI CHODRON

* pristine, conscious awareness
** a being who chooses to forego full enlightenment to return reincarnated on Earth to continue to help all sentient beings

H.H. Dalai Lama: A Blessing, 2005
Video
21 minutes, 27 seconds

TIBET

ARTISTS:

Phil Borges

Bernard Cosey

Peig Fairbrook & Adele Fox

Richard Gere

Helen Mayer Harrison & Newton Harrison

Tenzing Rigdol

*"The roots of all goodness lie in the
soil of appreciation for goodness."*

—The Dalai Lama

IN THE SEVENTH CENTURY, holy men from India brought the Buddha's message of wisdom and compassion to the Roof of the World, the Himalayan plateau of Tibet. Though the kingdom was then largely occupied by nomads and shamans, the message of the Buddha was quickly adopted, and it has permeated Tibetan culture ever since. Tibetans became keepers of Buddhist wisdom, and its teachings thrived, sheltered from the rest of the world by the country's daunting geographical borders.

During the Cultural Revolution, China claimed control over the region, and the Red Army forced thousands of lamas and sages to choose between imprisonment or exile. Many, including His Holiness the Dalai Lama, fled. There was, however, a hidden blessing in this otherwise tragic end to the independence of Tibet. When Tibet's precious vessel of teachings cracked open, the dharma—the body of knowledge set forth by the Buddha—flooded out into the world.

Tibet, now referred to as the Tibetan Autonomous Region, lies at what some call "the third pole," where the most dramatic collision of tectonic plates in history occurred. The average elevation in the region is 12,000 feet. It shares Mount Everest with Nepal and is also bordered by India, the Kingdom of Bhutan, Burma, and the People's Republic of China. The Chinese are aggressively developing Tibet, building highways and railroads in once-pristine and sacred landscapes. Large numbers of Chinese are also migrating into the plateau, placing its natural resources at risk. Six of the world's largest rivers drain from the plateau: the Indus, the Brahmaputra, the Salween, the Mekong, the Yangtze, and the Yellow River. Over half of the world's population lives in the drainage basins of these six rivers.

Joel Makower

the dalai lama and the rivers of tibet

IT IS IMPORTANT TO GIVE a clear presentation about the land," instructed the Dalai Lama. "Not just the beauty or some animals, but the emphasis on the major rivers and their source of life."

It was a rather unexpected response from His Holiness, who had just been briefed on the themes of this art exhibition. He listened with interest and immediately homed in one particular theme—"Tibet: The Land and Its People."

His concern is well founded. The campaign to "save Tibet" is rooted deeply in the politics of our day: the human rights, political freedoms, and cultural independence of a great and peaceful people. But the story is far more than political. Tibet's fragile ecology is essential to Tibetans' material and spiritual needs, and to that of its neighbors. And the past half-century of neglect is taking its toll.

The problem, explained His Holiness during my visit to Dharamsala in 2005, is that Tibet's rivers flow downstream through the rest of Asia, including Cambodia, China, India, Laos, Pakistan, and Vietnam. And many of these rivers—the Arun, Brahmaputra, Indus, Machu (Yellow), Mekong, Salween, and Yangtse—are suffering due to the large-scale deforestation and mining taking place at these rivers' Tibetan origin. The devastation is having a drastic

effect not just on Tibet's ecology, but on the downstream countries. The area irrigated by these rivers, from the Machu in the east to the Indus in the west, provides sustenance for roughly half of Asia's population.

"Within my lifetime, the glaciers in Tibet have melted quite rapidly," His Holiness said. "According to some scientists, we will see changes to all the major rivers in a few decades because of less snowfall and warmer air. That means that the whole north of India will suffer from drought. For this reason, the unnecessary exploitation of Tibet's natural resources has to stop. It is of immense importance to inform the public that the ecology in Tibet needs special care. The communists recklessly use natural resources for two reasons: first, they are ignorant; second, they don't care."

It isn't just the rivers. The conversion of lands to agriculture for Chinese settlers has become a grave threat to Tibet's grasslands, which had been sustainably harvested by generations of Tibetans to feed herds of yak, sheep, and goats. This transformation has led to extensive desertification, rendering the grasslands unusable for agriculture, grazing, or any other productive use.

And then there is the land's growing population, the result of China's relocation of millions of its citizens to the region, where Chinese now outnumber Tibetans. In addition to putting Tibetans at an economic disadvantage, the Chinese migration progressively erodes the capacity of the region to provide clean air and water and other critical resource needs.

It will only grow worse. China has unveiled an ambitious fifteen-year plan to make Tibet one of the world's leading tourist destinations. A Chinese firm has launched a luxury rail service between China's main cities and Tibet's capital, Lhasa. Backed by private Western investment, the service aims to attract both newly wealthy Chinese and overseas tourists.

And with the burgeoning growth of tourists, population, and infrastructure come even greater assaults to the environment. Tibet is rich in aluminum, coal, and zinc, which have been difficult to exploit because of poor transportation links to the region. The new railway will allow for more efficient extraction and distribution. Other infrastructure projects are designed to divert Tibet's rivers to provide power and other benefits to the Chinese population and industries. Many of the environmental, human, and cultural tolls of such projects are borne by the Tibetans, who are displaced from their homes and land.

"Two centuries of limited population is okay," the Dalai Lama explained. "But much increased population in those lands is of great damage to the ecology. So, one of our real fears is the rapidly increasing Chinese population. They are causing great damage not just to Tibet's ecology, but also to its culture."

Ours was a brief conversation—about twenty minutes in all—but it was an unexpectedly ecologically focused one. Saving Tibet turns out to be about much more than saving Buddhism and the Tibetan culture. It is literally about saving Tibet: the land, its rivers, and all of their life-giving properties. ◉

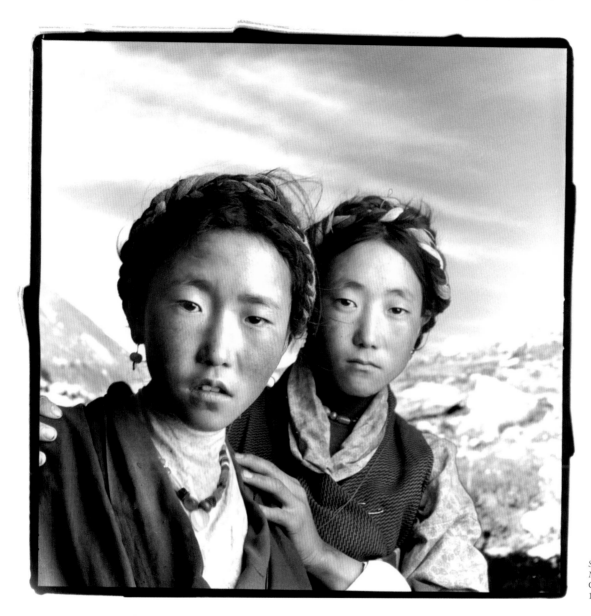

Shelo & Benba,
Nyalam, Tibet, 1994
Gelatin silver print
14 × 11 inches

Phil Borges

Shelo and Benba, best friends since childhood, are currently working as hostel maids in Nyalam, an old Tibetan village that has recently become a stopover for climbers en route to Mt. Everest. As Tibetans, they are rapidly becoming an insignificant minority in their own country because of the massive influx of Chinese into Tibet.

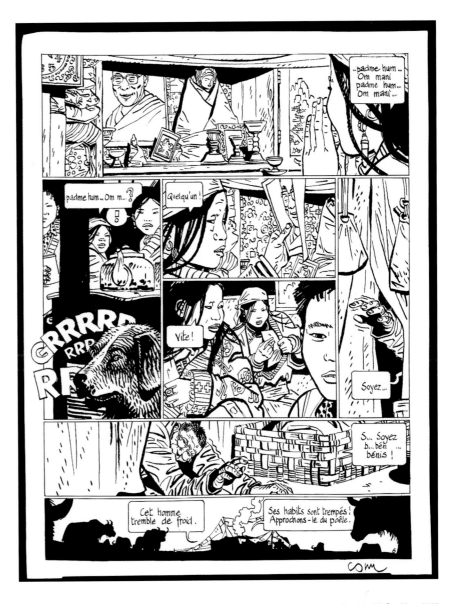

Om Mani Padme Hum, 2005
Black and white cartoon on heavy paper
20 × 16 inches

Bernard Cosey

Cosey's comics are not the classic adventure stories in which heroes save the world or catch the thief. His characters are individuals on a quest to reconcile themselves with their pasts and their memories. Often his characters, like the most famous, "Jonathan," must make great journeys in order to find their peace. These thirteen stories take place in the Himalayas and will be published as comic books. Cosey visits Nepal, Central Tibet, Amdo, and Kham looking for documentation and inspiration, in the footsteps of his characters.

two Tibet

23

Peig Fairbrook & Adele Fox

The theme represents the inseparable aspect of the people of Tibet with the Dalai Lama. In Tibet there are four types of banners conveying good will and Buddhist teachings. This influenced the construction of the piece, with the panels sewn to hang freely from the background.

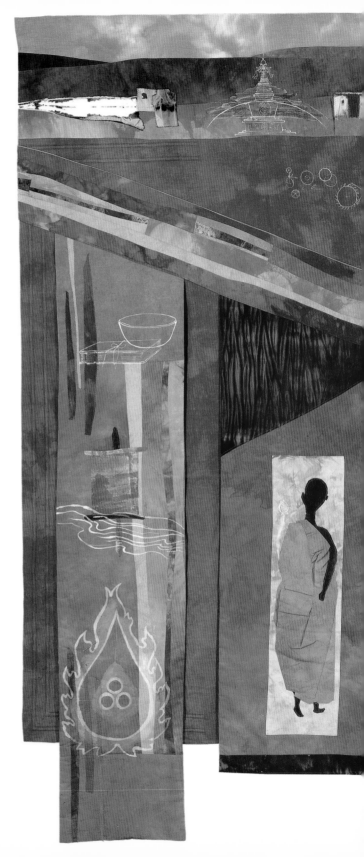

Symbol of Peace, 2004
Fabric wallhanging
20 × 87½ inches

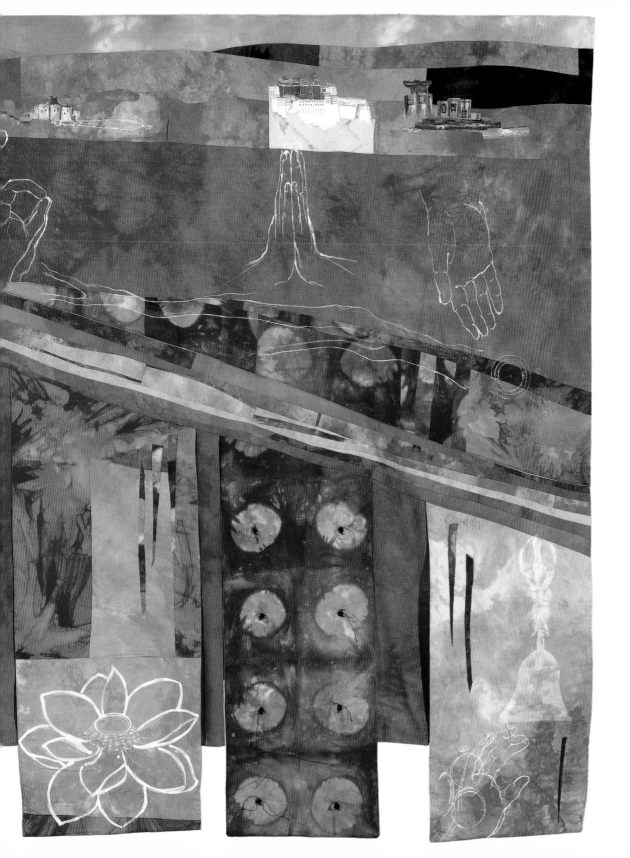

Helen Mayer Harrison & Newton Harrison

On my birthday an old friend, a neuroscientist from the university, came into our studio and asked, given the nature of our work, what I thought about the idea of His Holiness for a peace park.

I said, "His Holiness who?"

He said, "Why the Dalai Lama, of course."

I said, "Tell me about the Peace Park."

He handed me a book and opened it to first one quote then another.

"If our generation exploits everything available—the trees, the water, or the minerals—without any care for the coming generations and the future, then we are at fault, aren't we? But if we have a genuine sense of universal responsibility as our central motivation, then our relating with the environment will be well balanced."

"It is my hope and dream that the entire Tibetan Plateau will someday be transformed into a true peace sanctuary: an entirely demilitarized area and the world's largest natural park or biosphere."

He said that our work might interest the Dalai Lama.

I said that His work certainly interested us. He said he was going to India to meet with His Holiness on various matters and would discuss our work with Him and would we write a greeting to the Dalai Lama.

So we offered greetings:

GREETINGS:

"We hold that the ocean is a great draftsman.
In response to our millennia of manipulation of fire,
the Ocean has answered gracefully
By rising slowly,
And moment by moment
Redrawing the shorelines of the world.
And as the oceans rise gracefully
Changing all boundaries
And means of production
The ways of all living beings will change as well.
To this continuously graceful drawing and redrawing
Can we respond
By withdrawing with equal grace
To the High Ground?
It seems to us that envisioning Tibet as a World Peace Park,
Certainly High Ground,
Is an act of equal grace."

The Dalai Lama responded to us a first through our friend, who turned out to be the Dalai Lama's science advisor, finding common grounds in our greetings. Then, later, directly to us, encouraging us to proceed.

We told him, "We have the notion that all countries downstream from Tibet, along the Indus, Brahmaputra, Ganges, Salween, Mekong, Hwang-Ho and Yang-tse Rivers, share common interests and concerns relating to the effects of overgrazing, abusive agriculture, deforestation, and desertification of Tibet since these countries share the undesirable downstream consequences of impoverishment of riverine life and shore line habitats. Thus, we feel that all these countries downstream from Tibet could have an interest in sharing in the process of rebuilding the ecology and we are beginning to search for a metaphor that might draw their interests together."

Therefore,

FOR THIS PROJECT, WE INTEND

To create a very large scale model of Asia, where Tibet as the High Ground is manifest and the Seven Principal Rivers are clearly stated. This model would make clear the implications of the deforestation of Tibet for the many nations of the continent of Asia.

To come to a clarified statement of the research on the outcome to the rivers, riverine life and riverine surrounds including the dams and other river projects, in other countries as well as Tibet, of the deforestation of Tibet.

To develop a conceptual design for the regeneration of Tibetan forest, farm and meadowland. We would hold that a conceptual design for this kind of transformation carries a moral force in advance of criticism of any kind.

After all,
Tibet is the high ground
and the high ground is the hardest to generate
and the easiest to lose
We began to think about Ranil Senanayake's analog forests and a new
life web for Tibet.

To develop a conceptual model that envisions a probable life web for the deforested areas of Tibet. This ecological model, working with the idea of analog forest, or a simplified woodland-rainforest ecosystem, would also have yields of recognizable value to those who inhabit the surrounds. The process would suggest an analog for the forest that once existed, less complex than the original, but nonetheless with overstory, understory, canopy and appropriate niches. This forest would also serve to conserve existing or replaced topsoil and protect riverine and wetland ecologies first—in Tibet proper and then in the countries below.

More is at stake here than the simple regeneration of a new kind of forest. The forest knits Tibet, China, Nepal, Kashmir and all the bordering countries together from an ecological point of view. The rivers which spring from Tibet are also waters that bind these countries. We would hold that a conceptual design expressing these understandings can be the basis for generating a conversation based on common interest as opposed to conflicting interest.

We hold that putting in place a working model of this kind is a necessary addition to the present discourse on saving the Tibetan culture, peoples and children and to preserve the terrain from emerging abuses such as atomic waste dumping.

Helen Mayer and Newton Harrison 1991

And now, 15 years have passed. Climate change is acknowledged. Ecological consciousness has grown. The poor management of forest reconstruction in the region has been documented. The difficulties arising of fragmented responses to severe whole systems degeneration are manifest, and in no place more than the sites in Tibet where the Seven Sacred Rivers begin. We propose that the time is now to begin again a visioning process leading to action on the ground, of what a sustainable whole systems concept would be. Creating an analog, as it were, to what once existed there.

Our belief that the time is now is bolstered by the growing ecological consciousness worldwide and the massively increasing body of ecological knowledge that now exists. It is time to begin again by gathering the information necessary, forming the teams necessary, sequestering the funds necessary, creating the words and imagery necessary, creating the consensus necessary, toward considering the well-being of the seven sacred rivers that emerge from the Tibetan plateau, and the watersheds and all within these through which the waters flow.

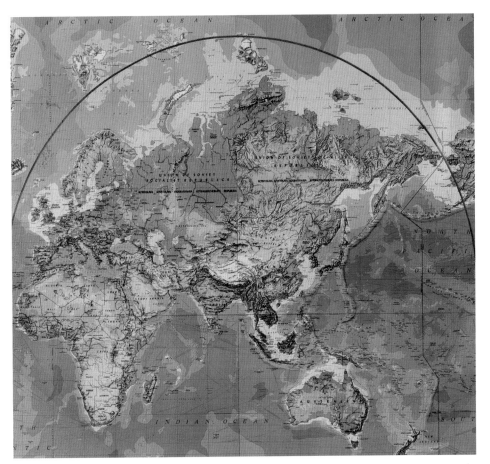

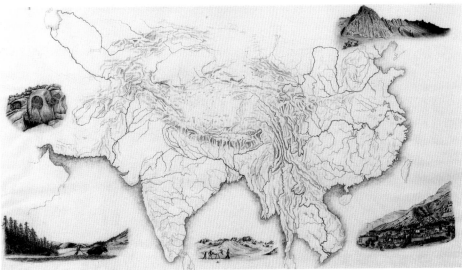

Tibet is the High Ground, 1991-2006
Relief map and drawing
10 × 8 feet

Neljorpa from Amdo, 1996
Platinum photograph
15⅞ × 10 ⁹/₁₆ inches

Richard Gere

The Tantric yogi photographed is from Amdo, the area of the Dalai Lama's birth, in northeastern Tibet near the Chinese border.

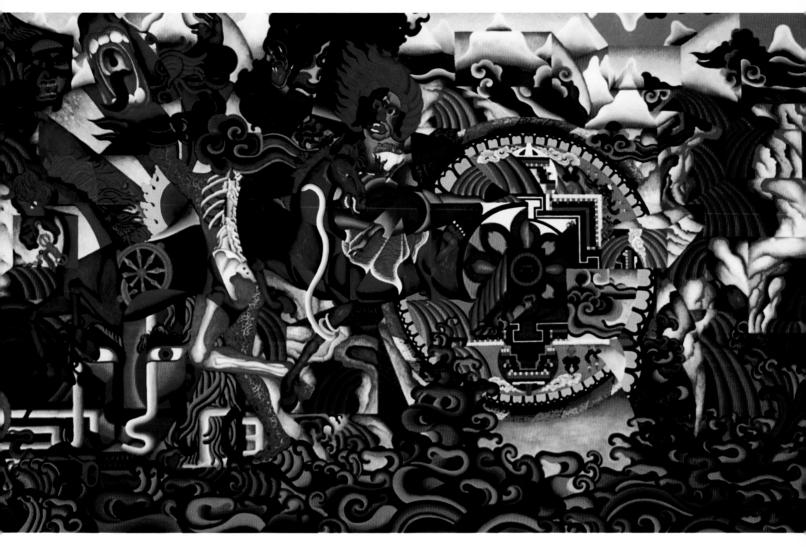

Tenzing Rigdol

Brief History of Tibet, 2003
Acrylic on canvas
6½ × 10 feet

"The struggle for Tibet is an instrument for me as an artist to express the universal ethics that stand on the pinnacle of nonviolence."

3

BELIEfS

ARTISTS:

Yumyo Miyaska

Lewis deSoto

Doris Doerrie & Michael Wenger

Era & Don Farnsworth

Louis Fox & Free Range Graphics

Tri Huu Luu

Andra Samelson

Kimsooja

"This is my simple religion. There is no need for temples; no need for complicated philosophy. Our own brain, our own heart is our temple; the philosophy is kindness."

—The Dalai Lama

I T IS SAID THAT BUDDHA had eighty-four thousand unique methods of teaching—from simply watching the mind or practicing compassion to elaborate visualizations—each leading to liberation. The path is rich with practices, symbols, beliefs, and rituals that are available to those who consider themselves Buddhists, as well as those who simply feel that the teachings are in accord with their own heartfelt beliefs. At the center of all the teachings, one finds compassion. His Holiness has a special ability to make the message accessible to both followers and others by speaking in terms that resonate with contemporary thinking. He is not, however, updating the sacred teachings, or dharma. The essence of dharma never changes, but the vehicle by which it is transmitted can be adapted to the surrounding culture. When tea is poured from a teapot into a cup, the tea does not change, only the container. Buddhist temples can be ransacked, the Buddhas of Bamiyan blown to pieces, but the dharma remains intact.

Professor Robert Thurman

tibetan buddhism and beliefs

BUDDHISM IN OUR ERA IS FOUNDED on Shakyamuni Buddha's discovery that absolute reality is bliss, which he called Nirvana. Our sufferings are caused only by our misunderstanding of that reality. The whole of Buddhism, then, is a huge, diverse, educational, scientific, ethical, and religious curriculum seeking to help us correct the misunderstanding and develop a truly realistic understanding, called wisdom, of the nature of Reality. Beliefs are not as important to Buddhists, then, as understandings. However, some provisional worldviews or beliefs are more useful, and some are less useful in the evolutionary enterprise of developing the essential understanding.

Tibetans live their beliefs in a concrete way. Buddhists consider that belief or faith should be reasonable. Faith is not opposed to reason. An unreasonable faith is considered weak, and could be harmful, in case it was seriously misguided. One need not believe what is contrary to good sense. Therefore, the Tibetan's religious world view is in many ways the same as his or her scientific world view. Tibetans do not have the split-reality-sense of the Westerner.

Tibetans are spiritual in the sense that, while only few have achieved full enlightenment in each generation, they all have the taste for freedom and ultimate, evolutionary perfection, free from all suffering. They believe that they and all beings will eventually attain the goal of

perfect freedom, knowledge, and happiness, which they call "buddhahood." They believe that there are buddhas living among them all the time, remaining by reincarnation in the world in order to help beings find their own freedom. They believe that human life itself is a fabulous opportunity, acquired by their own evolutionary efforts. They in particular feel they are lucky to be born in Tibet under the direct care of their beloved and effective messiah, Chenreysik. They cherish their access to living buddha teachers, while enjoying broad social support for study, training, and contemplative adventures; or at least enjoying daily association with others who are well on their way. They feel that their life situation should be used to advantage by engaging in conscious evolutionary growth.

Most Tibetans are not "primitive," often simplistically defined as lacking self-conscious individuation and living unreflectively in nature. Their spirituality is not a simple animism, nor is it a nationalistic theism. They do have a sense of the aliveness of the world, the presence of good and evil spirits of many varieties. Buddhism never tried to eradicate any layer of human feeling, any sense of connectedness with life. On the contrary, it opened people up to their many-faceted natures by means of its unique teaching of selflessness, voidness, or freedom. From thirteen-hundred years' exposure to this wisdom teaching, Tibetans' culture supports a deep sense of the ultimate voidness of the world, its final reality of freedom. They feel that life is beyond capture by any conceptual system, and that all perspectives on life are relative, changeable, and open to creativity.

Even uneducated Tibetans feel intuitively that their sense of self has an illusory quality; it is not as real as it seems. They do not feel they do not exist; rather, they are aware that states of seeming obliteration are just as unreal as states of absolutized presence. They sense that the ultimate void is just the freedom to participate in inexorable relativity.

It is difficult for Tibetans to become fanatical about anything, since they are ensconced in a culture based on this fundamental Buddhist insight of relativity. This is why the Chinese communists failed to enlist Tibetans' ideological fervor in the thought of Mao. Tibetans could easily see the usefulness of the social ideals, but they could not work up a fanatical allegiance. They recognized the distortion in the theory of materialism and the practice of class violence. They saw the idiocy in the fanatical cult of Mao as a divinized personality. They couldn't be trained, even by the most brutal torture and violent tactics, to give up their sense of the presence of benevolent enlightened beings. Their sufferings, even deaths, were taken by most of them as opportunities to practice patience, tolerance, love, and compassion. Some still did resist with force, felt humanly compelled to act violently under assault. But they had a hard time becoming fanatical, so ingrained is their sense of relativity. In 1979, when the Chinese abandoned their bloody campaign to suppress religion, they were astounded that the Tibetans went back first to their spiritual lifestyle, before rebuilding their farms and households. They began to rebuild monasteries, stone by stone. They sought ordination and became monks and nuns. They began again to carve OM MANI PADME HUM on rocks and mountainsides, counting mantras on their rosaries, turning their prayer machines, prostrating down the highways on year-long pilgrimages, and so forth. The Chinese had to accept that thirty years of thought-reform, class-struggle, and strenuous torture had not made a dent. The Tibetan spirituality was still deeply rooted in their hearts.

Tibetans believe that all life, including their own, is beginningless. All have been born and reborn infinitely in the past in infinite different life forms. Each has been a god, a titan, a human, an animal, a pretan, and a hell-being—innumerable times. Each is thus genetically related to every other human, god, animal, demon, and so on. Every other being has at one time or another been our mother, father, lover, brother, sister, enemy, and each of us has been all those roles to every one of them. Tibetans have very little interest in ancestors, no cult of ancestor worship. They feel naturally that ancestors are reborn as beings alive around them here and now, not sitting around in their past forms in an ancestral heaven or happy hunting ground.

Tibetans further believe that their present thoughts, words, and deeds will determine their future destiny in infinite future lives. They are sensible enough to not want to be again a hell-being,

a starving pretan, an animal, a demon, a suffering human embodiment. They want to regain a human life as good or better than their present one, they want access to the secrets of positive evolution, they want to achieve freedom and perfect enlightenment.

Tibetans are as diverse as any other nation. There are the educated elite, the advanced practitioners, well-educated monks, and intellectually cultivated nobles. There are also ignorant monks and nobles. Then there are the commoners, with town-dwellers being more literate and sophisticated than country folk. Then there are the truly lowly, the beggars, the corpse cutters, and then tribal peoples on the borderlands. There are various levels of spirituality among these various peoples.

If possible then, it is best to become a monk or nun, to gain maximum freedom from distractions, free from concern for family, possessions, livelihood, status, and so forth, in order to put twenty-four hours a day into inner development through study, investigation, and contemplation. The society is structured practically to allow the maximum number of individuals to enter those institutions. If that is not possible for an individual with no inclination or with inescapable obligations, then at least he or she can support other religious persons, for the pleasure of their presence and their blessings. And anyone can be a temporary professional seeker, on holidays, after retirement, on pilgrimage, in daily prayers. And then there are the many mechanisms on automatic: there are prayer machines driven by human effort, by wind, water, or fire; there are intercessors who can be commissioned to generate merit; and so forth. Promoting personal evolution toward ultimate buddhahood was definitely the national industry of Tibet. Tibetans today are surrounded by this orientation in whatever is left of their unique "art of freedom" culture.

Yumyo Miyasaka

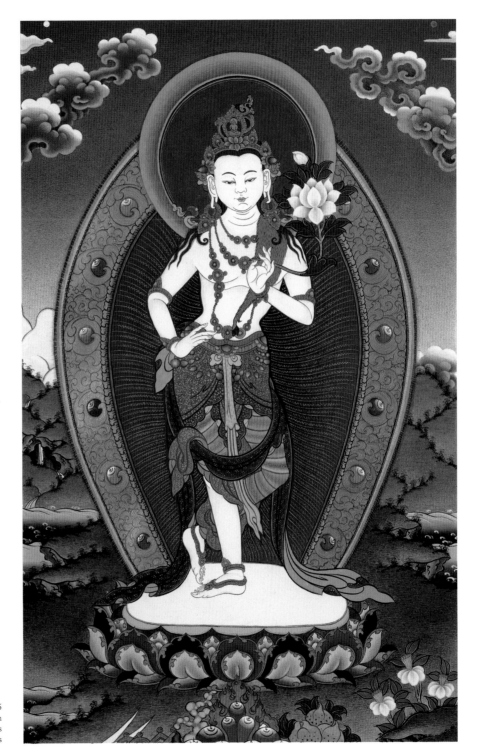

Avalokiteshvara (Chenrezig), 2005
Tibetan thangka painting in
natural mineral pigments
21 × 13 inches

Lewis deSoto

In Buddhist scriptures, Shakyamuni Buddha remained on the earth after attaining enlightenment in order to teach others his insights into achieving salvation. At the age of eighty he came to Kushinagar, where he preached his final sermon and died. This episode is the Paranirvana, the physical death of the historical Buddha and his entering into Nirvana, the state of oneness and perfection. This work by deSoto was occasioned by the loss of his father; he has superimposed his own face on the Buddha as he asks the universal question, "How will we all face the moment of our death?"

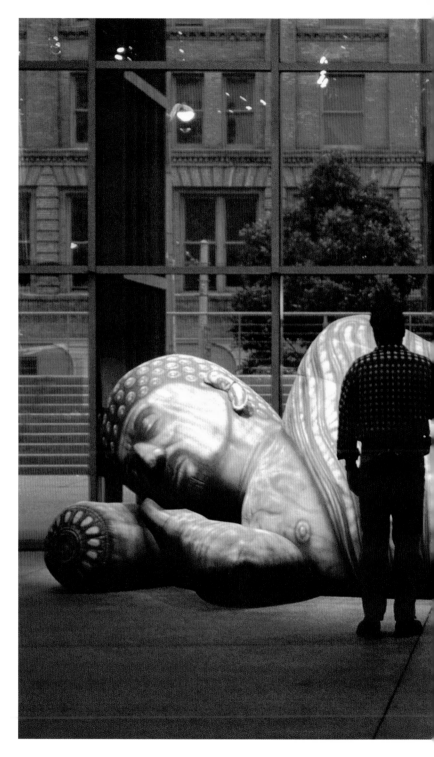

Paranirvana, 1999
Mixed media with nylon, painted cloth
7 × 25 × 6 feet

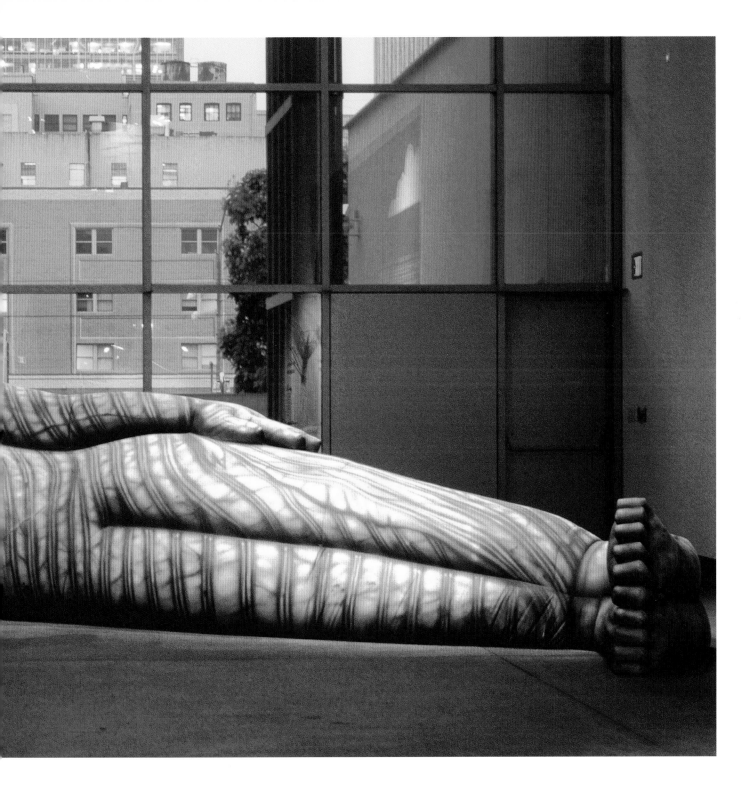

Doris Doerrie & Michael Wenger

The Ox, 2006
DVD
30 minutes

The images in the video, dating back to eleventh century China, depict ox herding and the cycle of practice of a Zen student/teacher. Using traditional poems and pictures, *The Ox* was filmed at the Tassajara Zen Mountain Center. As timely as it is timeless, it follows a youth's journey of transformation. From the search for the ox to the return to the marketplace, this story evokes the maturation of the serious seeker.

Era & Donald Farnsworth

In *Dharmakaya*, Donald and Era Farnsworth
use elements of the Tibetan thangka to explore
nonhuman manifestations of divinity. A thangka
is a religious artwork, usually painted on silk,
intended as a guide for contemplative practice and
experience. Most often traditional thangkas depict
various aspects of Buddhist cosmology with one
featured deity in the center surrounded by at-
tending deities or monks. *Dharmakaya*, however,
excludes any figures represented in their human
form, drawing attention instead to what would
ordinarily serve as the thangka's background:
stylized representations of the heavens, the earth,
the sun, and the moon.

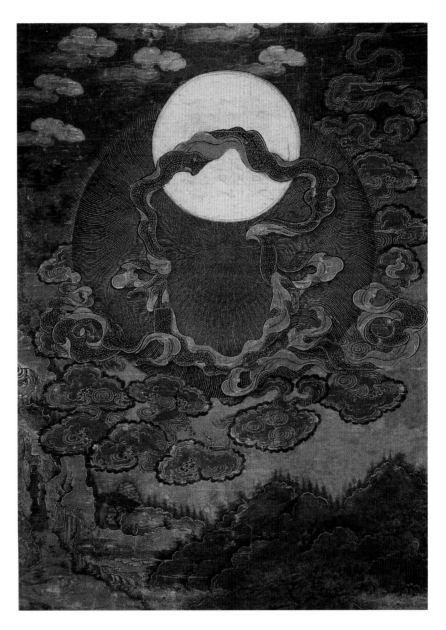

Dharmakaya, 2004
Jacquard tapestry, cotton
116 × 79 inches

Louis Fox & Free Range Graphics

The work reverberates with the Buddhist mantra, *Om Mani Padme Hum*, which translates as "The jewel of compassion and the lotus of wisdom dwell in the innermost heart." The notion that ultimate wisdom and compassion are already within each of us is communicated.

Om Mani Padme Hum, 2006
Projection, video animation
40 × 40 inches
3 minutes

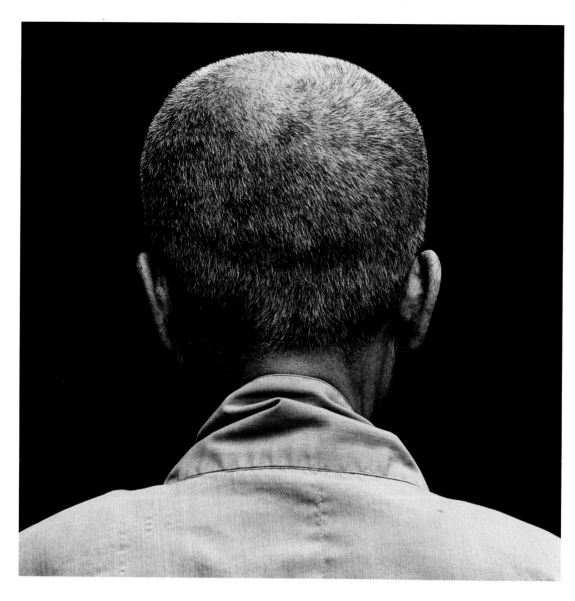

Head Series, 2002–2003
Gelatin silver print
30 × 30 inches

Tri Huu Luu

"Three years ago, I began photographically exploring the Buddhist idea of detachment in relation-ship to individual identity and perception of other. I embarked on an ongoing meditative series of photographs of the backs of the heads of monks and nuns in Asia. By detaching from a person's looks and abstracting his or her presence to the shapes and patterns of a shorn head, I wanted to show the ultimate truth that we are essentially all the same and therefore should not judge others by our differences."

Andra Samelson

Samelson's work pays homage to the peace and splendor of the two colossal statues of Buddha destroyed by the Taliban forces in Bamiyan, Afghanistan, in 2001. Despite the destruction of these great statues, the wisdom and the power of the Buddha's teachings have not been diminished, and although the Dalai Lama has not been allowed to return to Tibet, he is still delivering his message of peace, compassion, and tolerance throughout the world.

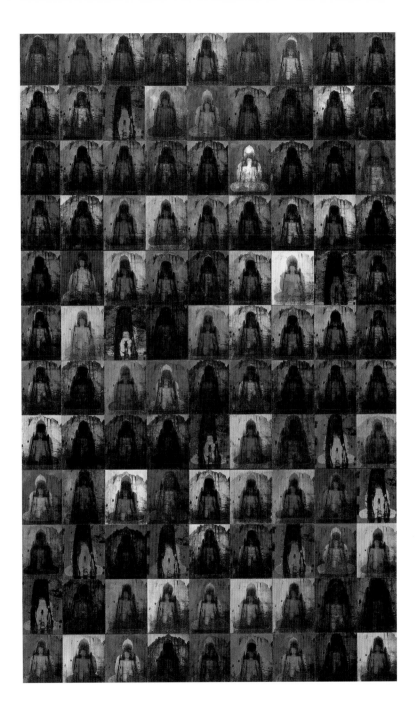

Bamiyan: A Continuum, 2001
Ink and acrylic on rice and wood panels
10 × 6 feet

Kimsooja

Kimsooja's desire to explore cultural and physical differences and the varied characteristics of human relations transported her to cities around the globe to film this video series. In *A Needle Woman*, Kimsooja's lone figure is seen lying on her side on a high rocky ledge. Every subtlety of the shifting landscape is revealed: the sky brightens and darkens as the sun dips behind the gently rolling clouds, the branches of a tree flutter, the artist's dress flaps lightly in the wind. In this serene contemplative scene, nature and the human figure fuse and a sense of timelessness emerges. Kimsooja investigates the concept of the performer, as the artist becomes an egoless conduit through which viewers can ascertain meaning.

In her installations, Kimsooja uses fabric and textiles preciously and ceremoniously. They can be found strung on washing lines disappearing endlessly and timelessly into mirrored space. They are cast as performers—mute, still witnesses to the presence of the onlookers in much the way that Kimsooja has witnessed the onlooker in her many acclaimed performance pieces. Although without a strong feminist ideology, Kimsooja's work is delicately and essentially about a universal female perspective. Fabric is woven primarily by women. It wraps, encloses, and protects the body.

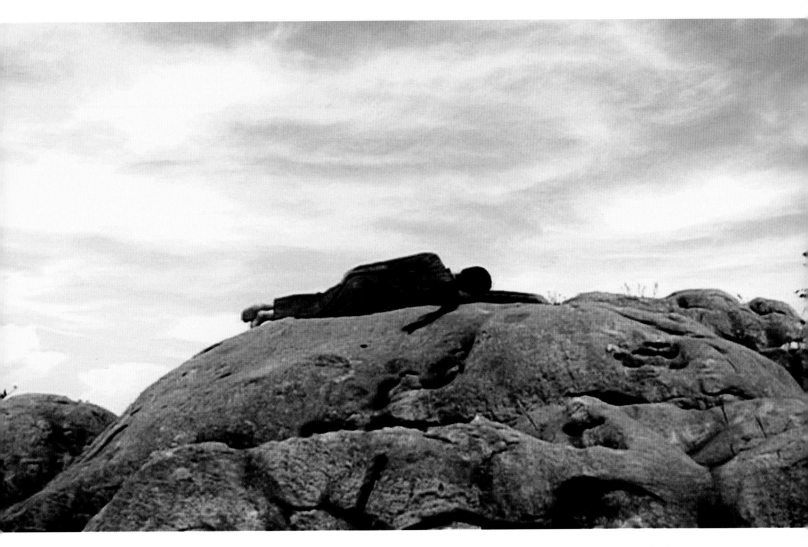

A Needle Woman—Kitakyushu, Japan, 1999
Video
6 minutes

4

EMPATHY AND COMPASSION

ARTISTS:

Artist unknown

Guy Buffet

Jenny Holzer

Binh Danh

Jim Hodges

Jesal Kapadia

Enrique Martínez Celaya

Gabriela Morawetz

Ryuichi Sakamoto

"If you want others to be happy, practice compassion. If you want to be happy, practice compassion."

—THE DALAI LAMA

BUDDHISTS BELIEVE THAT clinging to a sense of self
is a fundamental cause of suffering. We can spend a
lifetime struggling to protect our interests, our reputa-
tion, our honor, but to what end? The antidote to that suffering is
compassion for others. The religions of the world seem to agree
at least on this one point: there is an inextricable link between
personal happiness and the kindness one extends to others. A
compassionate attitude naturally follows upon the recognition of
the interdependency of all people and phenomena. If we are all
interconnected or, as some believe, if all phenomena are merely a
projection of the mind, how can an individual attain true happi-
ness while others suffer?

　　Compassion in action is not only the feeling of sympa-
thy for others but also having the desire to relieve them of their
suffering. It is not merely a happiness that is achieved but also a
cessation of unhappiness. So in a sense, one of the best tools avail-
able to create peace today is the simple admonition to put yourself
in the other person's shoes. The Dalai Lama has made it his life's
work to send this message out into the world.

Noa Jones

meditation on creativity

CREATIVITY IS THE MOST PRIMAL INSTINCT of humankind; without it we would not exist. Creation is the work of Zeus, Shiva, and the biblical God – and on particularly productive days when the juices are flowing, creativity can make us humans feel like we exist on their level. It is easy to see why the ecstasy of procreation and artistic creation are often compared to the ecstasy of heightened religious experience. Anyone coming out of the studio after an intense creative session can attest that there is a sense of bliss, however defined, when the creative instinct or spirit is being satisfied.

Even if we are not artists, we are constantly creating. Office managers, chefs, parents, even warlords, are pressed to think creatively, and sometimes they do so to the degree of becoming artistic. But we look to artists to push the outer limits of our understanding. While we all perceive the world through our own particular lens, artists share theirs in such a way that alters our own view – sharpening, focusing, diffusing, coloring, and in many ways enhancing our own experience.

A freshman art student walking into Figure Drawing 101 faces his first nude. All his filters are called to attention – perception of angles, light, color; perceptions of erotic thrill or disgust; embarrassment; competition; his preconceptions about good and bad art. One of the first things the teacher must do is break these concepts. Betty Edwards writes in her classic, *Drawing on the Right Side of the Brain*, "At least part and perhaps much of what we see

is changed, interpreted, or conceptualized in ways that depend on a person's training, mindset, and past experiences. We tend to see what we expect to see or what we decide we've seen. Learning perception through drawing seems to change this process and to allow a different, more direct kind of seeing."

Meditation masters often speak of filters when discussing our experience of the world at large. The same filters that enhance our experience can be seen as the obstacle to pure perception. Art can be used as means to purify perception and break habits.

Artist Sanford Biggers explores the potential of meditation, as both a means to produce art and integrate contemplative themes into his work – his impressive urban graffiti art installations rendered in multicolored sand and destroyed by break dancers were modeled after Tibetan sand mandalas. His shows are successful but, like many artists, he still finds himself questioning what he is doing and why he is doing it.

The answer comes when he finds his bliss. Even prior to his introduction to Vipassana meditation, Biggers found a need to decompress before initiating any work, sometimes just sitting in a chair and staring into space. "Now I realize it is a form of meditation. I am aware of things. When I get into that decompression and I begin to work, I no longer have those questioning thoughts. My body takes over and allows me to get into that zone."

Many consider that zone to be an end unto itself. But it could be taken a step further. Get into the coveted zone and then renounce the zone. With the acknowledgment of the essenceless of even seemingly positive experiences of "good" art, the selfishness of the art disappears. Though it would appear antithetical for some artists to pursue egolessness, the rewards can be awesome. "From a spiritual point of view, true creativity means breaking out of the sheath of egocentricity and becoming a new person, or, more precisely, casting off the veils of ignorance to discover the ultimate nature of mind and phenomena," writes Matthieu Ricard in his book *Monk Dancers of Tibet*.

It is more widely accepted that art is a result of a person's individual expression, his or her attempt to record personal impressions of their experience. But until the dawn of the modern era, most art was religious in nature and was considered, as French writer and dramatist André Gide put it, "a collaboration between God and the artist, and the less the artist does the better." The position of the artist was merely a channel for the divine.

"The seventeenth-century academic approach to painting was getting away from one's perception to get to a higher, more significant level of awareness – a moral, religious ideal whose message it was the task of the artist to transmit," says Joachim Pissarro, curator at the Museum of Modern Art in New York City and grandson of one of the avatars of impressionism, Camille Pissarro. "Artists, therefore, had to be wary of their perceptions. To the eyes of the academics, the nineteenth-century impressionists were perceived as being vulgar lowlives because they dared pouring out their perceptions on the canvas. Raw perceptions were considered crude artistic materials."

In his 2005 exhibition *Pioneering Modern Painting: Cezanne and Pissarro 1865–1885*, Pissarro brought the filtering process of the artist into sharp focus. "[Cezanne and Pissarro] were in fact rather highly aware of their own individual perceptions. … But what is unusual about their situation, and what links it with [this discussion], is the fact that they were willing to, and interested in, interacting with each other [and] confronting the limits of their individual perceptions. … In that sense they were throwing a bridge between the perspectives of East and West."

Matthieu Ricard describes the gap between the two as such: "In the West, we usually understand creativity to be the expression of the impulses that arise from personal subjective experience. For the contemplative this approach is not necessarily creative in its fullest sense because that subjective experience itself is limited by basic ignorance. Thus what one considers to be an original creation is often the result of exploring one's habitual tendencies and impulses that maintain the vicious circle of *samsara*, the wheel of existence. Innovation, as we usually understand it, does not necessarily free us from ignorance, greed, or animosity or make us better, wiser, or more compassionate human beings."

And so we continue to create and destroy and create again. Within the scriptures, myths, and even books of science and logic, creation is intrinsically linked to destruction. Anything created, anything subject to time and space, is impermanent. One could say creativity elevates us because it has the potential to annihilate us, free us from the mundane "self." In sex one feels union with other, in religion one feels ultimate oneness, and in art, as Vincent Van Gogh described, "I put my heart and my soul into my work, and have lost my mind in the process."

John Geirland

buddha on the brain

I DIG OUT THE MERRIAM-WEBSTER Collegiate Dictionary that my son uses in his fifth grade class and look up compassion: "Sympathetic consciousness of others' distress, together with a desire to alleviate it." In other words, compassion is an emotion, a state of mind, an intention. A recent experiment revealed that compassion could also be a skill, the cultivation of which may profoundly change the behavior of the brain. The research came from a team of neuroscientists under the direction of Dr. Richard Davidson, director of the Waisman Laboratory for Brain Imaging and Behavior at the University of Wisconsin/Madison.

In the summer of 2002 Antoine Lutz, a French researcher in Davidson's lab, carefully placed 128 electrodes on the shaved head of a French-born Buddhist monk named Mattieu Ricard. No common monk, Ricard possesses a Ph.D. in cellular genetics and serves as the Dalai Lama's official French interpreter. Lutz instructed Ricard to produce a meditative state of "unconditional loving-kindness and compassion." Lutz quickly noticed something extraordinary in the raw EEG output—pronounced gamma waves (40 cycles per second) indicative of intense mental activity. What's more, he noted "synchronous oscillations" of gamma across different brain regions—like people scattered across the length of a sports stadium chanting above the din of the crowd. Amazingly, gamma persisted at high levels even after Ricard stopped meditating.

Davidson and his colleagues carefully examined their equipment, changed the electrolyte they used in the procedure and checked the arrangement of electrodes. More monks were recruited for testing—in total, eight "long-term meditators" (mostly Tibetan monks) who had a minimum of ten thosuand hours of meditation training under their saffron-colored belts. (One diligent subject had tallied up fifty thousand hours.) Not only did Ricard and the other monks produce more intense gamma activity than Davidson and his colleagues had ever seen before, but the gamma waves were thirty times stronger than those observed in a student control group. The part of the brain that showed the most intense activation was the left prefrontal cortex, the area associated with positive emotions.

The findings strongly suggested that pursuing a compassion-based meditation regimen in the Tibetan Nyingmapa and Kagyupa traditions—the approach used in the study—could result in changes in the brain associated with heightened consciousness. When Davidson and his group published the results in the prestigious *Proceedings of the National Academy of Sciences* in November 2004, it generated headlines around the globe.

Longitudinal studies are currently underway at the University of California–San Francisco and the University of California–Davis, to see if a true cause-and-effect link exists between meditation training and changes in brain function. Regardless of their outcome, I am impressed with the notion of spending ten thousand hours of one's life focusing the mind on "unconditional loving-kindness and compassion." Ten thousand hours is the equivalent of working a forty-hour week, fifty weeks a year for five years. How could that kind of prolonged, focused mental training not transform the brain? In point of fact, the traditional view of the human brain is that it develops early in life and becomes relatively fixed in adulthood. Think about how easily children learn new languages and how difficult it is for grownups to do so.

It has been only in the past twenty years that neuroscientists and psychologists have shown the brain to be a lot more plastic than anyone had thought. The key is training. Consider string musicians, who practice thousands of hours over a lifetime. The part of the cortex that controls the musicians' string fingers is larger than the area controlling the bow hand. The effect is true even for people who take up the violin after the age of forty. Just as thousands of hours of violin practice can change the motor centers of the brain, Davidson believes his study shows that intensive mental training can reorganize the brain's emotional centers. "Virtuous qualities of the human mind" like compassion, Davidson told a recent gathering, can be regarded as "skills that can be cultivated." Other researchers are following this lead to see if meditation can be helpful in reducing drug cravings and in the treatment of depression.

Davidson is one of the leading researchers on the neurological bases of emotion. Fifty-four years old, he has dark curly hair, an angular face and hawk-like nose. His clothes hang loose on his spare frame, and from a short distance he looks like a lanky adolescent trying on his first suit. A native of Brooklyn, he speaks without a trace of that borough's distinctive brogue, as if it had been surgically removed from his speech centers. He has been fascinated by meditation since he was a teenager, and in the '70s was a regular fixture at Ram Dass's informal Tuesday evening classes in Cambridge, where Davidson was pursuing a Ph.D. in biological psychology at Harvard. His work on emotion in the '80s led to an invitation by the Dalai Lama to come to Dharamsala in 1992 to conduct research on Tibetan Buddhist adepts. Years later His Holiness encouraged Tibetan Buddhist monks to make the journey to Davidson's lab in Wisconsin.

The Dalai Lama has had a lifelong interest in science, going back to his childhood when he uncovered a brass telescope belonging to his predecessor, the Thirteenth Dalai Lama. He trained it on the moon only to discover, contrary to Tibetan folk belief, that the moon doesn't have a rabbit in it. In 1990 he helped set up the Mind and Life Institute as a forum for a continuing dialog between contemplatives and scientists. He has said that he would like to see the development of a secular ethics and feels that some Buddhist practices, such as meditation, could be stripped of their religious aspects and made widely available to all for this purpose. It is for this reason that the Tibetan leader takes a special interest in Davidson's work. In his recent book, *The Universe in a Single Atom*, the Tibetan leader describes the collaboration between Buddhism and neuroscience as a "precious gateway into the alleviation of suffering, which I believe to be our principal task on this earth."

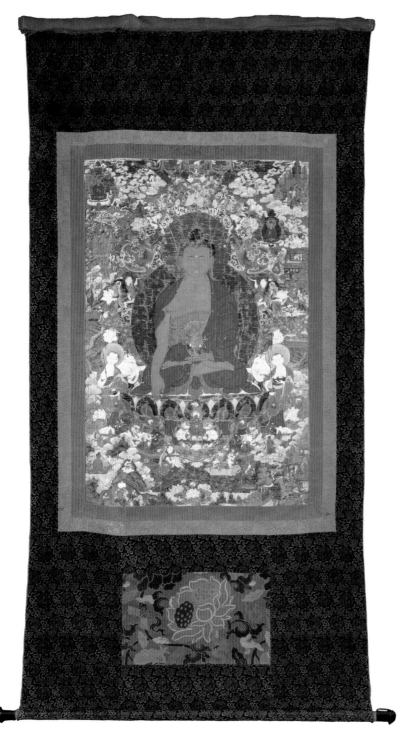

Artist unknown

The thangka was selected and loaned to the exhibition by the Dalai Lama from his personal collection.

The Dalai Lama's Thangka, date unknown
Canvas and silk
72½ × 43½ inches

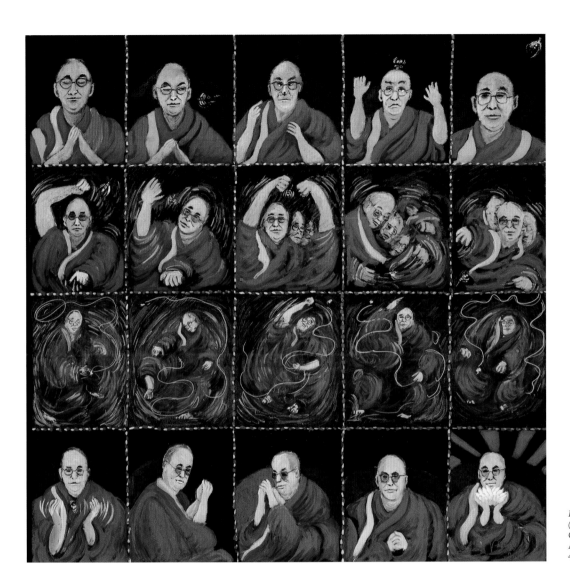

*His Holiness and the Bee
(How a Little Annoyance
Can Bring Great Joy)*, 2005
Acrylic on canvas
48 × 48 inches

Guy Buffet

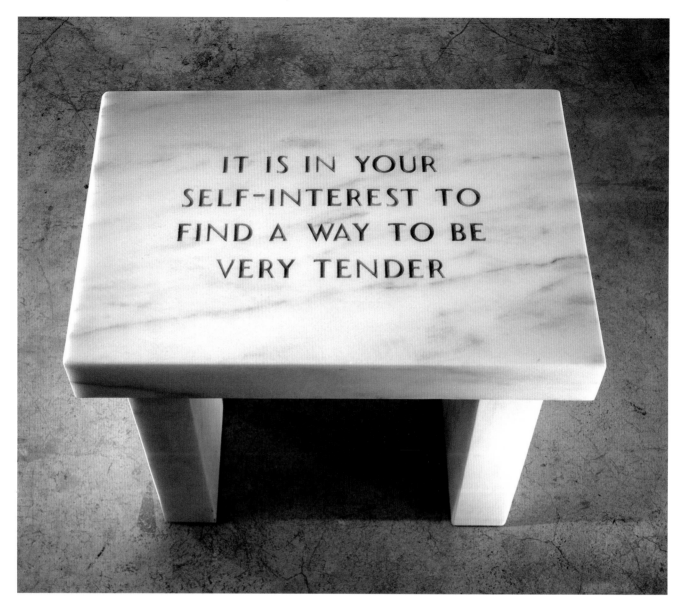

Selection from the Survival Series:
"IT IS IN YOUR SELF-INTEREST TO FIND
A WAY TO BE VERY TENDER," 1983–85
White danby imperial marble footstool
17 × 23 × 15¾ inches

Jenny Holzer

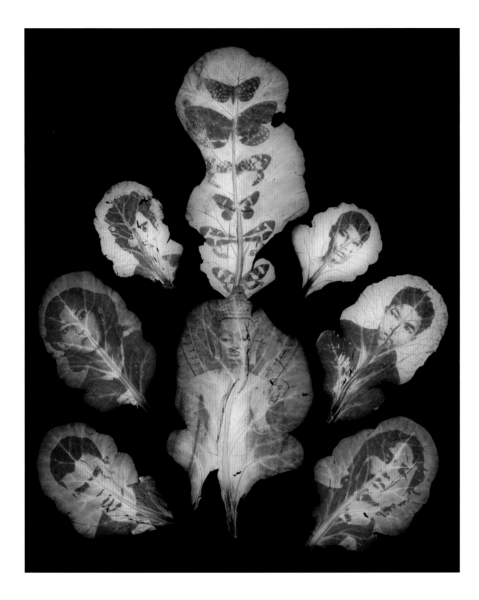

Universal Happiness Project, 2005
Chlorophyll prints and resin
25 × 19 inches

Binh Danh

Vietnamese-born artist Binh Danh uses nineteenth-century photographic techniques to burn images into plants. The artist develops his images on leaves, using chlorophyll as a medium.

"While in Phnom Penh three years ago, I visited Tuol Sleng, now the Museum of Genocidal Crimes. Between 1975 and 1979, some 1.5 to 2 million Cambodians died unnatural deaths from starvation, forced labor, torture, and execution by Pol Pot's Khmer Rouge regime. At Tuol Sleng, photographs of the victims are reminders of their once painful existence. But the agonies of these prisoners reach beyond the surface of the photographs."

When In There Is Out There, 2005
Mirror with contact cement on canvas
23 × 16 inches

Jim Hodges

"Like souvenirs of a lived experience, my interactive and ephemeral artworks mark the passage of time, compelling us to reflect on our own experiences of love, loss, memory, and longing. The use of light as an essential ingredient in my work taps its wide-ranging associations—spirituality, divinity, illusion, impermanence, inspiration, energy, and hope. Through the broken mirror, we can contemplate the complex and multifaceted nature of self-reflection."

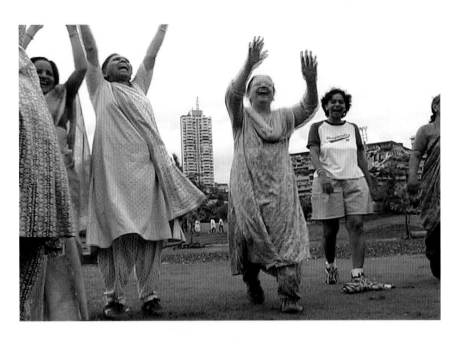

The Laughing Club, 2003
Video
9 minutes, 22 seconds

Jesal Kapadia

Laughing clubs, also known as laughter yoga, have become a popular phenomenon, both in the West and in India, where they originated. Based on laughter's therapeutic effect on the body, these clubs largely cater to city dwellers. This video visits one such club in south Mumbai, a global city set uneasily at the disjuncture of regional, national, and transnational processes. By gradually slowing the video in strategic places, the artist enables us to obtain a closer look at people's faces and their expressions.

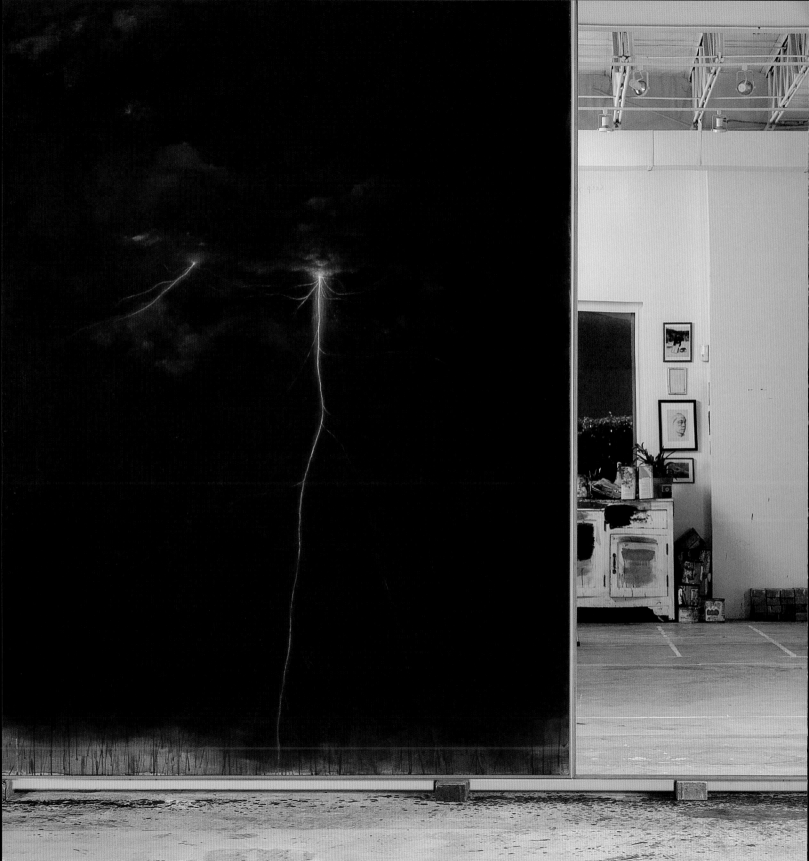

Enrique Martínez Celaya

The artworks of prolific Cuban-born painter, sculptor, photographer, poet, and writer Enrique Martínez Celaya mine the transient world of time and memory, identity and displacement. Martínez Celaya moves comfortably between intense emotional explorations and highly intellectual examinations. Through art, he addresses the search for purpose and truth, which create a pathway to ethical and responsible choices in work and life.

"Art clarifies the past and points to the future. It confirms that beauty is resonant with life and revels in the innate order of that beauty. Two flashes coexist in the work—a painted flash of lightning and a flash of consciousness as one moves from the painting to the mirror. The duality between the painting and mirror is a reminder of the path from oneself to all things—the foundation of compassion."

Untitled, 2005–2006
Mixed media
100 × 156 inches

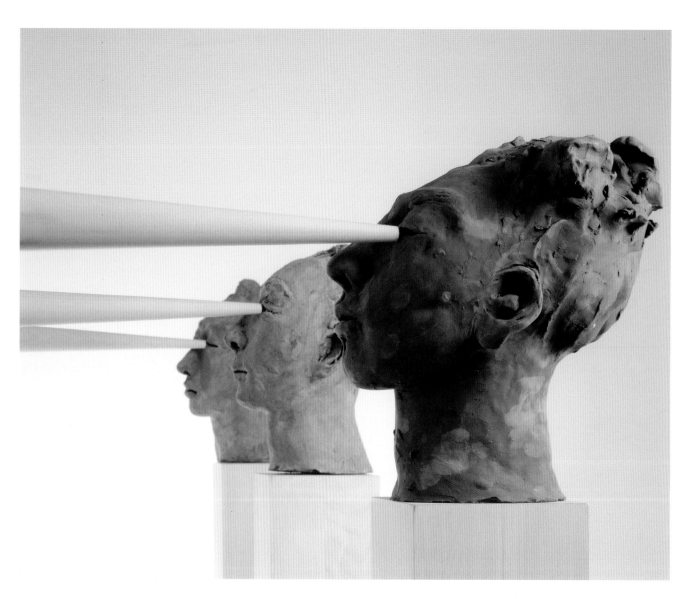

Gabriela Morawetz

Regarde, 2005
Terra cotta, wood, glass, lead
59 × 63 × 35 inches

The artwork of Polish artist Morawetz contains a strong magical aspect. The human being, the most important figure in her mystical universe, is removed from any particular time and place and belongs to a world of nature—one saturated with storytelling, spirituality, and mystery. In these works Morawetz has created an inner door, a kind of aperture to the world of others. By understanding others, she says, we become closer.

Ryuichi Sakamoto

Sound Mandala, 2006
Sand, table, chairs, speakers
Looped sound installation

"I wanted to know the answer to my questions about salvation for my first opera *Life*, so I went to Ladakh to hear the answer from His Holiness the Dalai Lama. At the very first moment when he walked into the room, I thought I saw a light coming from him. Without any reason, I knew he was the one at that very moment. In this sound installation, I wanted to express the compassion, gentleness, and serenity I learned from him. I improvised the piano very peacefully on top of the sounds of the Tibetan singing bowls, which are reversed and looped."

TRANSfORMATION

ARTISTS:

Laurie Anderson

Nefeli Massia

Filippo di Sambuy

Adam Fuss

Kisho Mukaiyama

Artist unknown

Yoshiro Negishi

Anish Kapoor

Adriana Varejão

Salustiano

Bill Viola

"Happiness is not something ready made. It comes from your own actions."

—THE DALAI LAMA

TRANSFORMATION OCCURS when causes and conditions are ripe for change. Sometimes this is a matter of years of hard work and sacrifice; other times it can come like a flash of lightning. It can take place deep in the psyche or on a societal level. And sometimes it is those changes that take place in the deepest recesses of the heart that accelerate the most global of transformations. Peace initiatives are often most successful when those who spearhead them approach peace with no personal agenda or need for recognition or praise. The Dalai Lama is living proof of such selflessness.

Teachers like the Dalai Lama are the alchemists who transform students into active participants. They illuminate the path to liberation. It is up to the individual, however, to transform suffering into nonsuffering, greed into generosity, ignorance into wisdom, selfishness into compassion. Individuals such as the Dalai Lama can shine a light down a path, but it is up to us to take a step forward.

Laurie Anderson

from the air

I LIVE IN DOWNTOWN MANHATTAN next to the West Side Highway right near a major tunnel into the city. And for the last three years my corner has been a police checkpoint and there are constant sirens, blockades. And during orange alerts, motorcades of police cars go screaming up the highway as they train for maneuvers and across the street hidden at the end of the pier there's the FBI headquarters.

And so lately I've tried to get out of town as much as possible and so I've been going on these long ten-day walks.

Last spring I decided to go to the mountains and the idea was to take a trip with my dog Lolabelle and spend some time with her and do a kind of experiment to see if I could learn to talk with her. I'd heard that rat terriers could understand about five hundred words so I wanted to see which ones they were.

Terriers are working dogs. They're all about security and they're bred to protect borders and so they do constant perimeter checks looking for any suspicious holes or breaks in the walls, little irregularities. So Lolabelle did her rounds around the house every day.

She also does a bit of herding so when new people come into a room she taps them on the knee with her nose to take a running count and then she trains her eye on the door, keeping track of the motion in and out.

But if someone leaves the room she can't subtract. (Let's see, ten minus one would be nine.) So she has to start counting all over again from the top. So this is a really time-consuming job.

I took Lolabelle to California, up into the northern mountains to a little isolated cabin near a Zen monastery. They brought food up from the monastery every few days but we never actually saw anyone. The bread and vegetables and supplies just appeared once in a while near the gate and so it was the ideal situation for an experiment like this.

It was February and the mountains were covered with tiny wild flowers. And every day was so beautiful that we just got up and went out and it was so dazzlingly peaceful—such a huge tall sky—very thin pale blue air and hawks circling. So every morning we just headed out and started walking and what happened was—more or less—beauty got in the way of the experiment. It was just so beautiful up there that I forgot about the whole project really. It just slipped my mind.

Most days we walked way down to the ocean, which took several hours, and we almost never saw anyone on the trails and Lolabelle would trot in front of me on the path—checking it out, doing a little advance work, a little surveillance.

And for fun sometimes she would drop back and hide behind a rock, and I would turn around and come running back up the path calling her name. And she would jump out from behind the rock, laughing her head off.

And then we'd keep on going, just sort of goofing around and checking out plants and lying down and having snacks of carrots.

Occasionally out of the corner of my eye I'd see some turkey vultures circling in this very lazy way, way up in the sky. I didn't think much about it. And then one morning suddenly there they were—swooping down right in front of me and I could smell them before I could see them—this wild and super funky draft of air, like somebody's really, really bad breath.

And I turned around and they were dropping down through the air—lowering themselves straight down vertically like helicopters with their claws open. And stopping, hovering, right on top of Lolabelle.

And it seemed impossible that they could just hover like that. And then I realized they were just hovering because they were in the middle of changing their plan. This white thing that had looked like a tiny white bunny from two thousand feet was turning out to be just a little too big to grab by the neck. And they were hanging there for a moment, weighing it, calculating, figuring it out.

And then I saw Lolabelle's face. And she had one of these brand new expressions. First was the realization that she was prey and that these birds had actually come to kill her. And second was a whole new thought; it was the realization that they can come from the air. I mean I just never thought of that. A whole one hundred and eighty more degrees that I'm now responsible for. It's not just the stuff down here—the paths and the roots and the ocean and the trees and smells and dirt. But all this too.

And the rest of the time we were in the mountains—out on the trails—she just kept looking over her shoulder and trotting along with her head in the air. And she had a whole new gait—awkward—her nose not to the ground following the smell but pointing straight up. Sniffing. Sampling. Scanning the thin sky. Like there's something wrong with the air.

And I thought, where have I seen this look before? And I realized it was the same look on the faces of my neighbors in New York in the days right after 9.11 when they suddenly realized, first that they could come from the air, and second that it would be that way from now on. It would always be that way. We had passed through a door. And we would never be going back. ◦

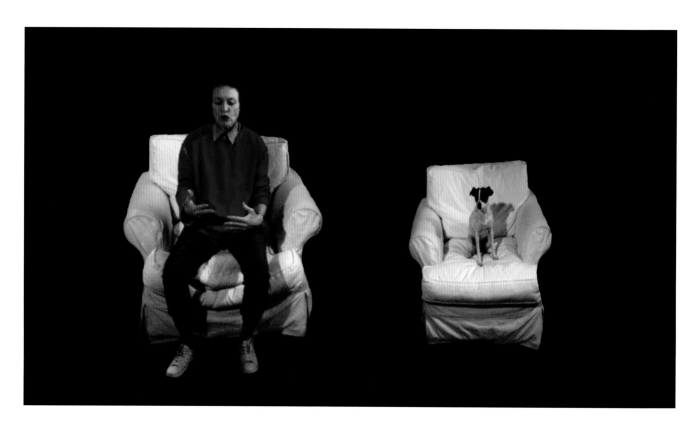

Laurie Anderson

From the Air, 2006
Video projection & installation
12 × 12 × 8 feet

"From the Air" is a story about awareness and scale from Anderson's solo performance, *The End of the Moon*. The video, projected onto a small clay figure, creates the illusion of looking at a very small person speaking in the corner of the room. This is part of a series of "fake holograms" that Anderson began in 1975 with a piece called *At the Shrink's*.

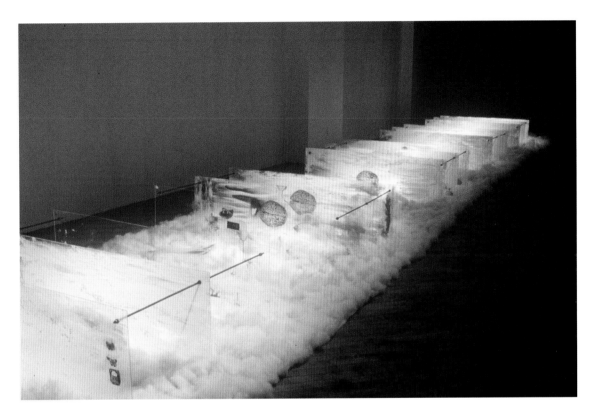

Dreamstorming, 1998
Mixed media
25 × 12 × 2½ feet

Nefeli Massia

Through a large-scale, multilayered installation and elegiac, translucent light-boxes, Massia creates images that seep beyond the frame and illuminate the wall. The exhibition space is viewed as a galaxy and the pieces of art as suspended fragments. The installation becomes a modern icon of the cosmos (brain) with an open passage to heaven (eternity).

Massia reaches out into deep space to embrace the cosmological dimensions of time: past, present, and future. Her work, both abstract and theoretical, probes the recesses of the psychological space of our physiology, the brain, to explore our sense of self. Notions of identity, consciousness, humanity, existence, and meaning are the keys to her ongoing search for knowledge.

Filippo di Sambuy

Through painting, di Sambuy creates symbols that arise from visions of his perception. The poetics of his artistic work always imply the appearance of a spiritual element. He believes that the "sacred idea" at the origin of a work of art does not conform to time. The Italian artist considers painting an immutable tradition, and as such, a unique activity to traverse the limits of time and space imposed by the choices of contemporary awareness. He sees the artist as a channel that tries to reveal the invisible by means of the visible, and thus embodies the divinity in a form or through a symbol through which he speaks and communicates with the observer.

Possible Painting Impossible Sculpture
No Ending Energy, 2005
Mixed media on canvas
38 ³/₁₆ × 98 ⁷/₁₆ inches

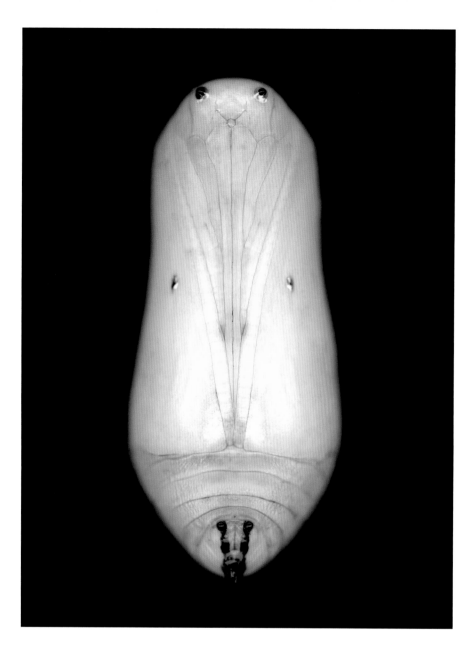

White Chrysalis, 2003
Pigmented ink-jet print
72 × 50 inches

Adam Fuss

The membranes of the pods invite us to linger over the caterpillar and, in the moment, recognize the transformative power of the crawler evolving into the luscious flying creature.

Kisho Mukaiyama

Sanmon WCC - yupotanjyu + nupotanje, 2005
Wax, oil paint
49 $^1/_2$ × 49 $^1/_2$ × 5 $^5/_{16}$ inches each

"I was born and raised on Mt. Koya, a sacred site of Japanese esoteric Buddhism, and meditation and faith have always been a part of my life. My work is an extension of this. I sense the profound existence of gods and Buddhas that cannot be seen with the eyes, just like the invisible spirit that animates the body. The main material of my work is molded wax. The colors are softly fused with the wax on the inside and they appear faintly like living organisms made of light through the white wax on the surface. They are like particles of mysterious light, the spirit residing in the body of the wax."

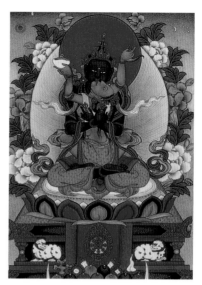

Artist unknown

Mahasiddhas, c. 1920s
Natural mineral pigments on canvas
On loan from private collection

The Tibetan meaning of *Mahasiddha* is an accomplished or enlightened person. The Dalai Lama is a contemporary Mahasiddha. The Mahasiddhas represent the path of self-realization through experience. Rather than being monks, these "Greatly (maha) Accomplished (siddha) Ones" were adepts of spontaneity and individuality. Coming from a wide spectrum of social backgrounds, these eighty-five individuals followed the path of the Tantric yogi/magician in order to attain liberation and enlightenment.

Yoshiro Negishi

Untitled, 2006
Acrylic on canvas
15 × 18 inches

"In watching the ever-changing mists and clouds rising about the mountains, I can lose all sense of time. In my paintings also, change is ever-present. From moment to moment, a different emotion is revealed. Catching hold of the delicate balance of these emotions as they appear, I attempt to bring out a condensed expression of these brief moments."

Anish Kapoor

Untitled, 2002
Two-plate white ground etching printed on paper
28 5/16 × 34 inches

Kapoor's work is engaged with deep-rooted metaphysical polarities: presence and absence, being and nonbeing, place and nonplace, the solid and the intangible. Through this interplay between form and light, Kapoor aspires to evoke sublime experiences that address primal physical and psychological states.

Adriana Varejão

Andar Com Fé, 2000
Photograph
30 × 24 inches

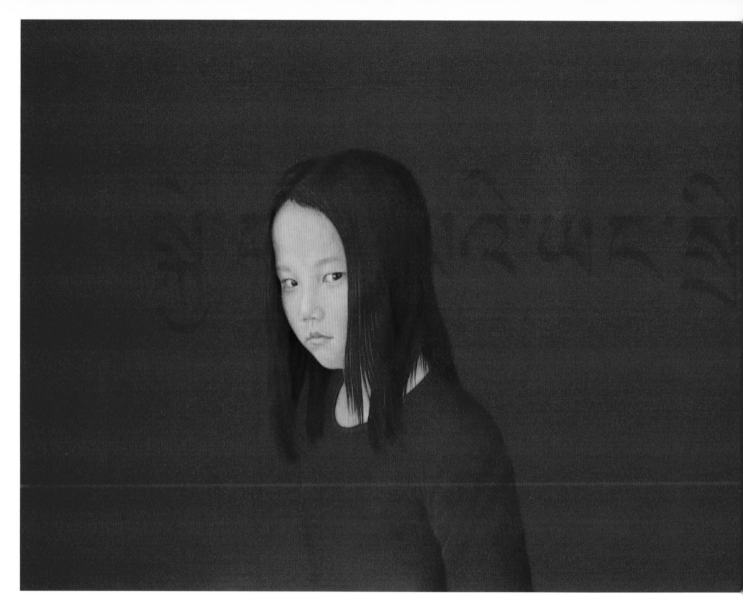

Salustiano

"Peace, compassion, forgiveness, generosity, happiness. Before I started this project, I interviewed lamas, rinpoches, monks, and other Buddhists. I required information to approach the subject of Buddhism in a non-superficial way. I asked them several questions regarding their vision of Buddhism. I did not get concrete answers to any of my questions. At the beginning, I was dissatisfied and disoriented. Little by little, I realized that they were not giving me closed answers. They were opening the door in order for me to travel my own way across this subject. They showed me the right direction and invited me to find my own answers. My intention is not to give you an instruction manual on how to interpret the artwork. Its theme is reincarnation and compassion and I intend to open a door not to a closed room but to an open field. This image is based on the idea of the Dalai Lama's reincarnation and his continued evolution and growth. The painting portrays the image of the Dalai Lama in his next incarnation as a young child and is a metaphor for growing, evolving, and transforming."

Reincarnation, 2005
Pigments and acrylic resins on canvas
4 ¹/₂ × 10 feet

Bill Viola

The male and female torsos shown here are tracked by a light, which traverses the bodies vertically, moving over the *chakras*—internal points of physical and spiritual energy. In the course of this process, we witness the dissolution of the figures into emptiness. Through his work Viola strives to connect the viewer with the image via the body as well the intellect. Believing that a special form of knowledge can only be gained through a direct and visceral experience of an event, he uses the video medium as an avenue to self-knowledge.

Bodies of Light, 2006
Video diptych
2 minutes, 6 seconds

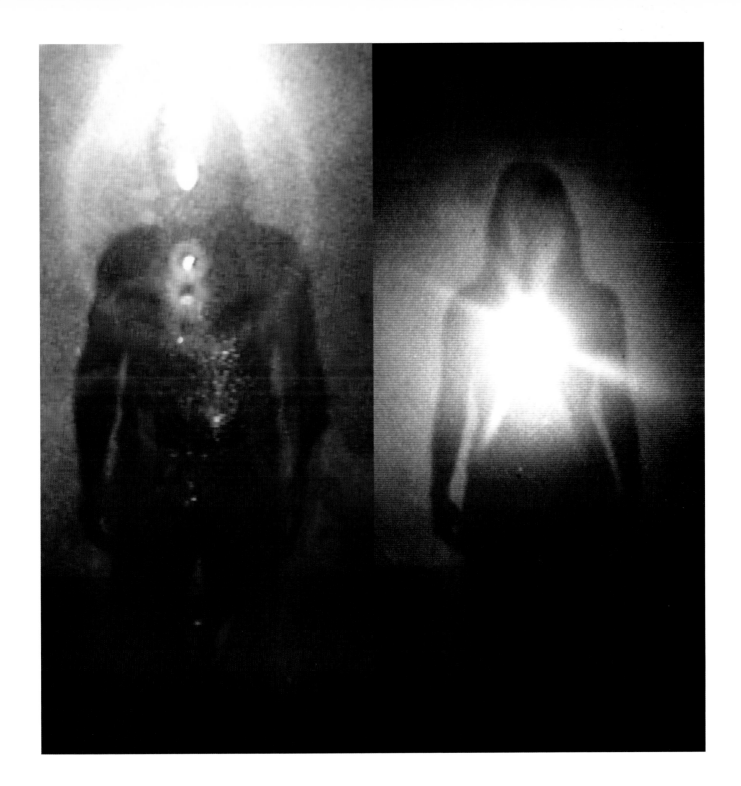

6

HUMANITY
IN TRANSITION

ARTISTS:

Tayseer Barakat

Sebastiao Salgado

Hoang Van Bui

Andy Cao

Ichi Ikeda

Dang Ngo

Jaune Quick-to-See Smith

Katarina Wong

"Our prime purpose in this life is to help others. And if you can't help them, at least don't hurt them."

—THE DALAI LAMA

WHEN THE EARTH IS VIEWED from outer space, its wholeness is revealed. Zoom in, however, and witness that it has been carved up and dissected, scarred with borders that isolate countries, populations, and natural resources. These divisions foment disagreements and resentment. Systems of alienation are created when the world is viewed by small minds poisoned by greed, hatred, ignorance, and pride. Sometimes only a simple wall or fence can separate two worlds—the rich from the poor, the free from the caged, the healthy from the sick. Six billion people call this planet home, but most feel allegiance only to tiny parcels of land, and many are ready to kill or be killed in order to defend these.

The result can be ethnic "cleansing," abject poverty, mass dislocation, and the permanent loss of natural resources and cultural treasures. Entire civilizations are uprooted and subjected to the powerful currents of political upheaval, natural or environmental disasters, and the whims of globalization. The Dalai Lama is himself a refugee, but rather than fight or give in to despair, he teaches love and compassion. He urges people to "settle the mind" and look directly at the nature of the destructive emotions that lie at the root of strife. When the layers are peeled away, commonalities are revealed, and aggression no longer seems necessary. He also teaches those who have already been swept from their homelands by the currents of chaos how they may move through transition with clarity, grace, and an open, compassionate heart.

Pico Iyer

messenger from a burning house

W HEN THE EARTH IS VIEWED from outer space its wholeness is revealed. It appears as one unit, one living organism, vibrant and whole. But zoom in and one can see that it has been carved up and dissected, scarred with borders that isolate countries, populations, and natural resources and foment disagreements, resentment, and dispute. Systems of alienation are created when the world is viewed by small minds poisoned by greed, hatred, ignorance, and pride. Sometimes only a simple wall or fence can separate two worlds—the rich from poor, the free from the caged, the healthy from the sick. Six billion people call this planet home but most have allegiance to only tiny parcels of land; many are ready to kill or be killed in order to defend those parcels.

The result can be ethnic "cleansing," abject poverty, mass dislocation, and the permanent loss of natural resources and cultural treasures. Entire civilizations are uprooted and subjected to the powerful currents of political upheaval, natural or environmental disasters, and the whims of globalization. The Dalai Lama himself is a refugee, a product of this movement. But rather than fight or despair, he teaches love and compassion. He urges people to settle the mind and look directly at the nature of the destructive emotions at the root of strife. When the layers are peeled away, commonalities are revealed and aggression no longer seems necessary. And for those who can't turn back, who have already been swept from their homelands

by the currents of chaos, he teaches how to move through transition with clarity, grace, and an open, compassionate heart.

In the Age of the Image, when some of us sit like the prisoners in Plato's cave, transfixed by the projections cast on the wall before us (and ignoring the reality at our backs), those who wish to grab our attention—and hold it—have to turn themselves into fairy tales, or "human interest stories" at the very least, that fit the simple contours of a child's parable: the boy from Hope, the peanut farmer from Plains, or the brilliant performer locked inside his Neverland. If the beginnings of their stories have the feel of fairy tale, so too—the logic goes—might the endings they promise to provide.

The Fourteenth Dalai Lama is in the curious position of attempting just the opposite: born in a cowshed in a remote Tibetan village and chosen by a search party of monks to be head of his people at the age of two, he travels the world ceaselessly to tell us, in effect, that he's not a character from fairy tale at all and that the suffering of his people is real, and desperate.

Already Tibetans are a minority in their traditional homeland. And they can still be imprisoned for twelve years by their Chinese occupiers if they are found with a picture of their temporal and spiritual leader.

The last time I was in Lhasa, the Tibetan capital, high-rise hotels and shopping malls and karaoke parlors blocked the view of the Potala Palace, long the center of classical Tibet. When a railway linking Golmud, China, to Lhasa is completed (in advance of the 2008 Olympics in Beijing), it is believed that Tibet, as an individual culture and self-contained land, could be gone forever.

The situation is so dire that parents from Tibet send their children on hazardous, twenty-day trips across the highest mountains on Earth in order to get to freedom and to learn about their culture and philosophy in Dharamsala, the ramshackle hill station in India where the Dalai Lama has made his home in exile for forty-six years. Mother will never see child again, but at least the child will know something of his motherland.

When the Dalai Lama travels out of Dharamsala and into the world, he comes to alert us to the fact that six million Tibetans could lose their homeland in a year or two. He arrives more or less as a messenger from a burning house.

We, however, need him to be a source of spiritual hope, and we long for him, implicitly, to be a miracle worker out of a fairy tale. "You come from the Land of Snows," we say, in effect, "full of monks who can fly and snow leopards and children who are named king at the age of two. Please give us some of your ancient wisdom." He says, in effect, "I'm a fallible man in the twenty-first century, and I need your help as you need mine."

In Dharamsala I spoke with a young Tibetan. "Please tell people … that the Dalai Lama and Tibet have a political meaning as well as a spiritual one," he said. The first principle Tibetan Buddhists honor, he might have added—one equivalent to God, you could say—is reality.

When the Dalai Lama offered philosophical teachings weeks before, at least eight thousand pilgrims packed the courtyard daily, a quarter of them foreigners. The day after the teachings ended, he gave a talk on Tibet's political situation, and the courtyard was noticeably less crowded, most of the people in attendance Tibetan.

How to try to preserve Tibet after half a century of occupation remains a tangled question: More and more Tibetans in exile, especially the young, believe the Dalai Lama is too conciliatory, too ready to forgive, and some urge attacks on Chinese power stations, roads, and even officials. When the Dalai Lama, who just turned seventy, is no longer around, it's possible that some Tibetans will turn, in desperation, to terrorism. His gamble—and hope—is that by taking the high road, and speaking for universal principles of tolerance and trust, he will gain some (mostly invisible) ground in the long run.

Those of us outside the Tibetan community face a very different, but no less urgent, task: As the Dalai Lama travels through the United States, those who long to see him, to touch him, those who are eager to bask in his infectious optimism and warmth, must also try to help him in the place where he needs it most: urging China to change its policies before there is no Tibet to save.

Otherwise we just seize the parts of his message that inspire us and ignore the parts that challenge us. In doing so, we become dangerously close to being children gathering around a spiritual godfather, hungry for his wisdom and hardly caring that his home, across the way, is going up in flames.

truth and reconciliation

MALUSI MPUMLWANA was a young enthusiastic antiapartheid activist and a close associate of Steve Biko in South Africa's crucial Black Consciousness Movement of the late 1970s and early 1980s. He was involved in vital community development and health projects with impoverished and often demoralized rural communities. As a result, he and his wife were under strict surveillance, constantly harassed by the ubiquitous security police. They were frequently held in detention without trial.

I remember well a day Malusi gave the security police the slip and came to my office in Johannesburg, where I was serving as general secretary of the South African Council of Churches. He told me that during his frequent stints in detention, when the security police routinely tortured him, he used to think, "These are God's children and yet they are behaving like animals. They need us to help them recover the humanity they have lost." For our struggle against apartheid to be successful, it required remarkable young people like Malusi. All South Africans were less than whole because of apartheid. Blacks suffered years of cruelty and oppression, while many privileged whites became more uncaring, less compassionate, less humane, and therefore less human. Yet during these years of suffering and inequality, each South African's humanity was still tied to that of all others, white or black, friend or enemy. For our own dignity can only be measured in the way we treat others. This was Malusi's extraordinary insight.

I saw the power of this idea when I was serving as chairman of the Truth and Reconciliation Commission in South Africa. This was the commission that the postapartheid government, headed by our president, Nelson Mandela, had established to move us beyond the cycles of retribution and violence that had plagued so many other countries during their transitions from oppression to democracy. The commission granted perpetrators of political crimes the opportunity to appeal for amnesty by giving a full and truthful account of their actions and, if they so chose, an opportunity to ask for forgiveness—opportunities that some took and others did not. The commission also gave victims of political crimes a chance to tell their stories, hear confessions, and thus unburden themselves from the pain and suffering they had experienced. For our nation to heal and become a more humane place, we had to embrace our enemies as well as our friends. The same is true the world over. True enduring peace—between countries, within a country, within a community, within a family—requires real reconciliation between former enemies and even between loved ones who have struggled with one another.

How could anyone really think that true reconciliation could avoid a proper confrontation? After a husband and wife or two friends have quarreled, if they merely seek to gloss over their differences or metaphorically paper over the cracks, they must not be surprised when they are soon at it again, perhaps more violently than before, because they have tried to heal their ailment lightly.

True reconciliation is based on forgiveness, and forgiveness is based on true confession, and confession is based on penitence, on contrition, on sorrow for what you have done. We know that when a husband and wife have quarreled, one of them must be ready to say the most difficult words in any language, "I'm sorry," and the other must be ready to forgive for there to be a future for their relationship. This is true between parents and children, between siblings, between neighbors, and between friends. Equally, confession, forgiveness, and reconciliation in the lives of nations are not just airy-fairy religious and spiritual things, nebulous and unrealistic. They are the stuff of practical politics.

Those who forget the past, as many have pointed out, are doomed to repeat it. Just in terms of human psychology, we in South Africa knew that to have blanket amnesty where no disclosure was made would not deal with our past. It is not dealing with the past to say glibly, "Let bygones be bygones," for then they will never be bygones. How can you forgive if you do not know what or whom to forgive? In our commission hearings, we required full disclosure for us to grant amnesty. Only then, we thought, would the process of requesting and receiving forgiveness be healing and transformative for all involved. The commission's record shows that its standards for disclosure and amnesty were high indeed: of the more than 7,000 applications submitted to the Truth and Reconciliation Commission, it granted amnesty to only 849 of them.

Unearthing the truth was necessary not only for the victims to heal, but for the perpetrators as well. Guilt, even unacknowledged guilt, has a negative effect on the guilty. One day it will come out in some form or another. We must be radical. We must go to the root, remove that which is festering, cleanse and cauterize, and then a new beginning is possible.

Forgiveness gives us the capacity to make a new start. That is the power, the rationale, of confession and forgiveness. It is to say, "I have fallen but I am not going to remain there. Please forgive me." And forgiveness is the grace by which you enable the other person to get up, and get up with dignity, to begin anew. Not to forgive leads to bitterness and hatred, which just like self-hatred and self-contempt, gnaw away at the vitals of one's being. Whether hatred is projected out or projected in, it is always corrosive of the human spirit.

We have all experienced how much better we feel after apologies are made and accepted, but even still it is so hard for us to say that we are sorry. I often find it difficult to say these words to my wife in the intimacy and love of our bedroom. How much more difficult it is to say these words to our friends, our neighbors, and our co-workers. Asking for forgiveness requires that we take responsibility for our part in the rupture that has occurred in the relationship. We can always make excuses for ourselves and find justifications for our actions, however contorted, but we know that these keep us locked in the prison of blame and shame.

In the story of Adam and Eve, the Bible reminds us of how easy it is to blame others. When God confronted Adam about eat-

ing the forbidden fruit from the Tree of Knowledge of Good and Evil, Adam was less than forthcoming in accepting responsibility. Instead he shifted the blame to Eve, and when God turned to Eve, she too tried to pass the buck to the serpent. (The poor serpent had no one left to blame.) So we should not be surprised at how reluctant most people are to acknowledge their responsibility and to say they are sorry. We are behaving true to our ancestors when we blame everyone and everything except ourselves. It is the everyday heroic act that says, "It's my fault. I'm sorry." But without these simple words, forgiveness is much more difficult.

Forgiving and being reconciled to our enemies or our loved ones are not about pretending that things are other than they are. It is not about patting one another on the back and turning a blind eye to the wrong. True reconciliation exposes the awfulness, the abuse, the pain, the hurt, the truth. It could even sometimes make things worse. It is a risky undertaking but in the end it is worthwhile, because in the end only an honest confrontation with reality can bring real healing. Superficial reconciliation can bring only superficial healing.

If the wrongdoer has come to the point of realizing his wrong, then one hopes there will be contrition, or at least some remorse or sorrow. This should lead him to confess the wrong he has done and ask for forgiveness. It obviously requires a fair measure of humility. But what happens when such contrition or confession is lacking? Must the victim be dependent on these before she can forgive? There is no question that such a confession is a very great help to the one who wants to forgive, but it is not absolutely indispensable. If the victim could forgive only when the culprit confessed, then the victim would be locked into the culprit's whim, locked into victimhood, no matter her own attitude or intention. That would be palpably unjust.

In the act of forgiveness, we are declaring our faith in the future of a relationship and in the capacity of the wrongdoer to change. We are welcoming a chance to make a new beginning. Because we are not infallible, because we will hurt especially the ones we love by some wrong, we will always need a process of forgiveness and reconciliation to deal with those unfortunate yet all too human breaches in relationships. They are an inescapable characteristic of the human condition.

We have had a jurisprudence, a penology in Africa that was not retributive but restorative. Traditionally, when people quarreled the main intention was not to punish the miscreant but to restore good relations. This was the animating principle of our Truth and Reconciliation Commission. For Africa is concerned, or has traditionally been concerned, about the wholeness of relationships. That is something we need in this world—a world that is polarized, a world that is fragmented, a world that destroys people. It is also something we need in our families and friendships, for retribution wounds and divides us from one another. Only restoration can heal us and make us whole. And only forgiveness enables us to restore trust and compassion to our relationships. If peace is our goal, there can be no future without forgiveness.

Untitled, 2005
Wood and text
embedded in glass block
18 × 18 × 16 inches

Tayseer Barakat

"I absent myself and you take me back to you . . . life's details steal me from you... your details surprise me at every single angle . . . I absent myself from you and then your children's touches on the window hurt me . . . the life electricity you use to communicate through the small holes shock me . . . the glance in your eyes while you are following the growth of your children hurt me. I see your eyes become filled with tears while you leave your children at the window . . . at night you dream of feasts, presents, weekend mornings, going home at the evenings, dinner, and the kiss of the dreamers of justice and freedom, waiting for the dawns filled with almond flowers . . . holding the stone of freedom . . . inheriting the adventure of riding the sea . . . spreading roses over the hells of the night."

Sebastiao Salgado

"The beach of Vung Tau in Vietnam is a fishing port and seaside resort close to the Ho Chi Minh City. It is probably from here that the largest number of "boat people" left in search of a better life. In 1975, when South Vietnam came under Communist rule, some 800,000 people left by boat, many from deserted beaches like this one. Where they ended up often depended on prevailing winds and currents: Hong Kong (195,000); Indonesia (121,000); Japan (11,000); Korea (1,300); Malaysia (255,000); Philippines (52,000); and Singapore (33,000)."

The Vietnamese Migration: the Beach of Vung Tau, 1995
Gelatin silver print
16 × 20 inches

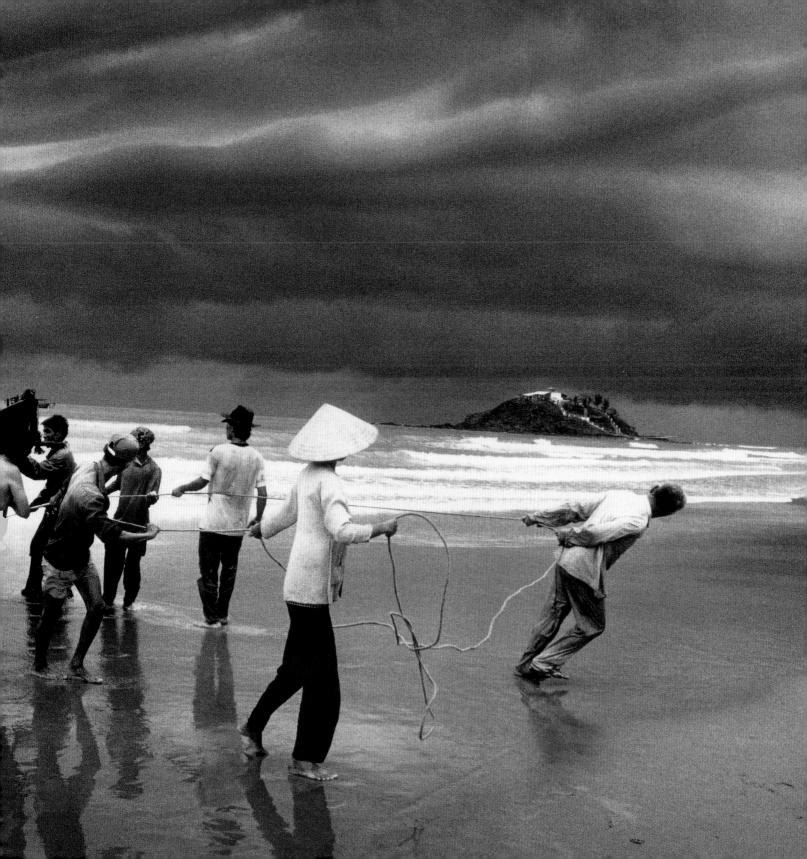

Hoang Van Bui

Passage #2, 1998
Mixed media
15 × 20 feet

"Often it is the materials from some gathered forces that draw me into the studio. In this installation, donated denim, peppers, and common rice help me recall my cultural fragrances. A freshly made oak box filled with white rice, like a sandbox, captures various periods of time in my personal passage. At the floor level, the strongly scented red chili pepper, sweet fragrance of white rice, and smell of old blue jeans are the familiar fragrances of my immigrant passage. Slowly, looking back to the past two decades, I can see changes. These changes are my red, my white, and my blue—all part of a mixed blessing as I search for an inner peace."

Andy Cao

A tribute to the orphaned children at the Ky Quang II Pagoda in Ho Chi Minh City, Viet-Nam.

The so-called "deaf coconuts" are undesirable rejects, symbols of the disabled children that Cao, a Vietnamese native now living in New York, met in an orphanage in Ho Chi Minh City. These children were abandoned at birth as a result of their physical impairments, believed to be the result of "Agent Orange," a chemical weapon used by the U.S. during the war there. The inclusion of gentle lullaby music speaks of hope and the universal need for nurturing and unconditional love.

100 Hearts, 2005
Deaf coconuts; oud oil
Dimensions vary
Vietnamese Lullaby by Huong Thanh

Ichi Ikeda

Ichi Ikeda considers water to be Earth's most precious resource and the medium that will help deliver our planet safely into the future. As a result, he has dedicated the majority of his prolific career to raising global awareness around water issues and conservation through international conferences, community activism, public performance and interactive WaterArt installations. Ikeda states that eighty liters is the minimum ration needed to support the daily life of each person on the earth.

80 Liter Water Box, 2004
Mixed media with photographs
66 × 52 × 20 inches

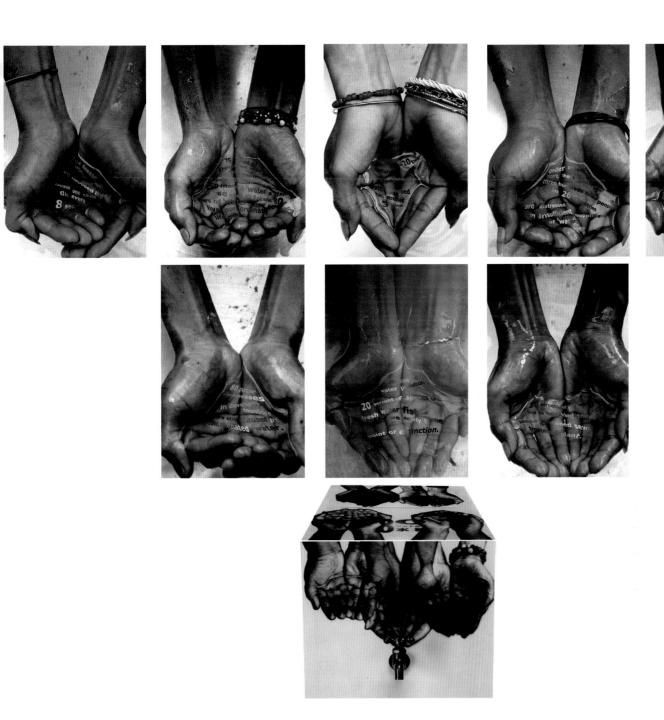

six humanity in transition

93

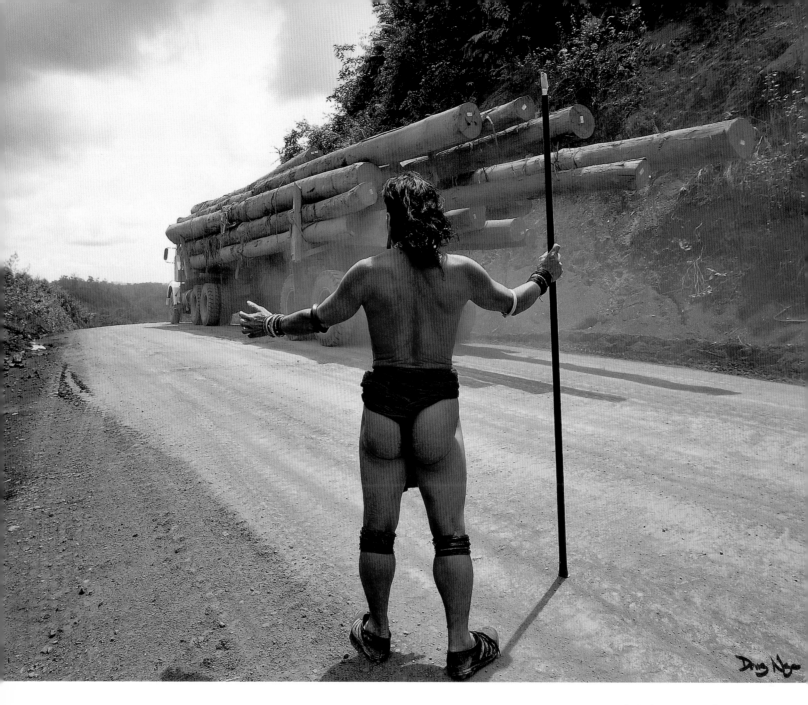

Dang Ngo

A Penan leader confronts a logging truck in Limbang District, Sarawak, Malaysia.

Penan Leader Confronts Logging Truck, 2002
C-print
11 × 14 inches

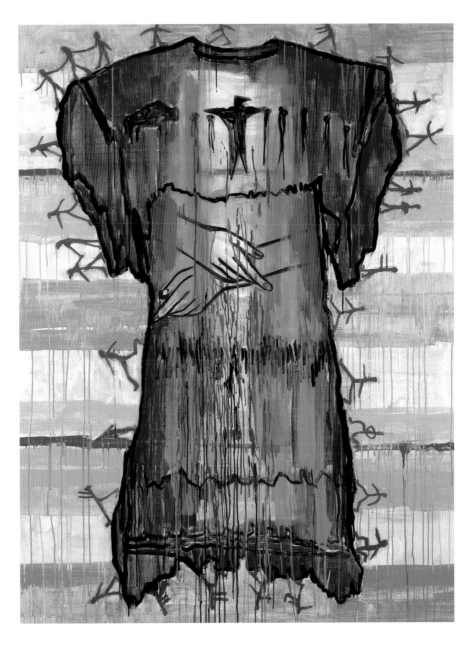

Jaune Quick-to-See Smith

Who Leads Who Follows, 2004
Oil and acrylic on canvas
80 × 50 inches

A traditional Native American woman's dress symbolizes the "Earth Mother" who gives birth to everything. Her hands make a motion of peace and on the perimeter of the dress human beings are depicted marching around the planet, all the same size. People need peaceful, respectful coexistence, and it doesn't work when one group oppresses another.

Katarina Wong

"My concerns as an artist are informed directly by my personal history. I am interested in ambiguous spaces; how the mind struggles to make sense of the unknown; and what happens when one acquiesces and surrenders to that ambiguity.

In 2000, I began a series of installations called *The Fingerprint Project* that use Lorca's poem as a starting point, drawing as well on the Buddhist concept of 'interdependent arising.' This idea asserts that all phenomena are tied together, meaning that what is experienced as objective reality is actually a co-creative experience entirely dependent on everyone's and everything's constant participation."

Terminus, 2005-2006
Wax & paint installation
8 × 16 × 2 feet

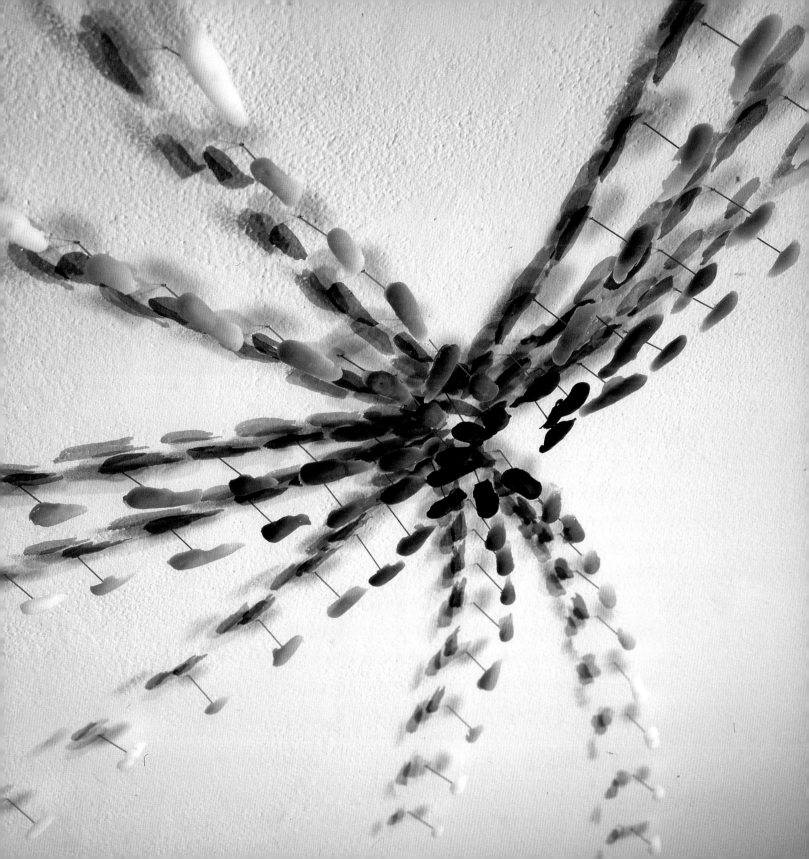

7

THE PATH TO PEACE

ARTISTS:

Jane Alexander

Santiago Cucullu

Dario Campanile

Tom Nakashima

Susan Plum

Tenzing Rigdol

Michal Rovner

Rosemary Rawcliffe

Yuriko Yamaguchi

Rupert Garcia

"In the practice of tolerance, one's enemy is the best teacher."

—THE DALAI LAMA

THERE ARE THOSE AMONG US who stand out as visionaries and icons. These individuals have the ability to sound a wake-up call to humanity, inspire and mobilize other visionaries, and point out paths that lead to peace. The Dalai Lama is such a person.

His Holiness has stated that the path to peace begins with oneself. From a peaceful heart the potential for greater peace radiates outward. A heart of compassion replaces a heart of self-preservation. The movement toward peace prevails when the peacemaker is motivated to benefit all beings without exception.

Arun Gandhi

nonviolence—The only hope

I T IS DIFFICULT TO RECONCILE Gandhian thought with the modern theory that nonvio-
lence is simply a strategy of convenience. In the words of Mohandas Karamchand Gandhi,
nonviolence "is not a coat that you can wear today and take off tomorrow." Although
Gandhi emphasized the need for spirituality in the practice of nonviolence, that was not the only
reason why he believed nonviolence must be a way of life. For Gandhi, living nonviolence was a
practical necessity. Unless one lives it, one cannot practice nonviolence. Just as we are required to
create a whole culture of violence around us to practice violence, we need to create a culture of
nonviolence around us to practice nonviolence.

The complexities of Gandhi's nonviolence need to be understood holistically and not dog-
matically. It is unfortunate that most scholars have looked at nonviolence only as the absence of
physical violence. We cannot appreciate the depths of nonviolence until we appreciate the breadth
of violence that is practiced in society today. Just as the absence of war is not peace, superficial
calm in a society does not indicate the lack of turmoil and conflict.

If Gandhiji was concerned about freeing India from the imperial clutches of Britain, he was
more concerned about freeing human society from the stranglehold of the culture of violence—a
culture that is so deep-rooted and pervasive that most of us have come to believe violence is our inher-
ent nature. There is a problem with this argument. If violence is indeed our nature, why do we need

martial arts institutes and military academies to teach us to fight and kill? Why are we not born with these instincts?

The fact is that it is not violence that is our true nature but anger, the fuel that generates violence. Anger is, to use an electrical analogy, the fuse that warns us of a malfunction. Sadly, we have learned to abuse anger instead of using it intelligently, because the culture of violence is based on the need to control through fear. Psychologists have recently concluded that an inordinately high percentage—over 70 percent—of the violence that plagues human societies everywhere is the result of the abuse of anger. Anger is an important emotion that plays a significant role in our lives and yet we have completely ignored it.

Does our ignorance mean there is nothing human beings can do to stop the abuse of anger? I believe we have the common sense and the capacity to learn and improve our nature. At Sevagram ashram in the late forties there were two things that Gandhiji stressed in our daily lessons. First, that we develop the ability to evaluate ourselves regularly—in the words of Socrates, "An unexamined life is not worth living"—and second, that we learn to channel anger into constructive use rather than destructive abuse.

He told us anger is like electricity—just as powerful and useful when used intelligently, but as destructive and deadly when abused. Like electricity, the energy of anger must be channeled intelligently to serve humanity constructively. Writing an anger journal is one way of recording the offensive episode for posterity. However, the intention should not be simply to get the anger out of one's system but to find an equitable solution to the problem that caused the anger. A problem nipped in the bud saves us from much grief.

Gandhiji also emphasized the need to understand the many ways in which humans practice violence. Apart from the physical violence—wars, killings, beatings, murders, rape, etc.—we commit an inordinately large amount of passive violence both consciously and unconsciously in the form of hatred, prejudice, discrimination, oppression, and in everyday ways such as name-calling, teasing, speaking and looking with disregard and disrespect based on financial status and sex, racially profiling people not known to us, and the millions of other ways in which our actions or even inaction can diminish and harm others. In the self-centered lifestyle focus of "me and mine" we don't see the plight of others, thus continuing to exhaust the planet's resources, hurling us on a crash course of economic imbalance and generating anger of global proportions. Passive violence is the fuel that will ignite physical violence—if we want to put an end to physical violence, we have to cut off the fuel supply.

We are building mega-urban societies around the world that lack soul and substance. We ignore the basic question—can a society be cohesive, compassionate, and caring if every member is taught to be selfish and self-centered? In Gandhian terms a society is an enlarged family and should possess the same positive characteristics—compassion and cohesiveness. However, the materialistic society we have created not only fosters selfishness but we encourage it in our children when we advise them to be successful at whatever cost. Passive violence festers in every society until it becomes unbearable and eventually explodes into physical violence. It brings into question our concept of justice. In a world steeped in the culture of violence, justice has come to mean revenge; an eye for an eye, Gandhiji said, only makes the whole world blind. In a culture of nonviolence, justice would mean reformation by recognizing that those who do wrong do it out of ignorance or attenuating circumstances. Punishing the person instead of resolving the problem only aggravates physical violence in the form of crime and violence.

The story of the starfish has an appropriate moral lesson for us. A man once went early in the morning to the beach for a walk. Dawn was still minutes away from breaking. In the haze he saw a figure near the water's edge picking something up and throwing it into the water. Out of curiosity he went to enquire and was told that during the night the tide came in and washed all the starfish ashore; when the sun comes out they will all perish. The curious man looked at the shoreline and saw thousands of starfish stranded. He said: "You aren't going to be able to save all these starfish so what difference is it going to make?" The Good Samaritan was still busy throwing the starfish and had one in his hand that he was about to toss into the water; he turned and said: "It will make a big difference to this guy." The moral clearly is that we should not be overwhelmed by the state of the world and do nothing to change it. Gandhiji believed that small acts of change can ultimately make a big difference. That is the essence of Gandhiji's message.

Jane Alexander

Harbinger with Rainbow refers to the challenges and potentialities of South Africa as a country transforming from authoritarian control founded on racial prejudice to a democracy, in the broader context of Africa and colonization. The figure portrays the symbolic relationship between oppressor and victim. The violent, aggressive, and powerful characteristics are shown in the same body that reveals helplessness.

Harbinger with Rainbow, 2004
Photo montage, pigment prints on cotton paper
16 1/$_2$ × 24 inches

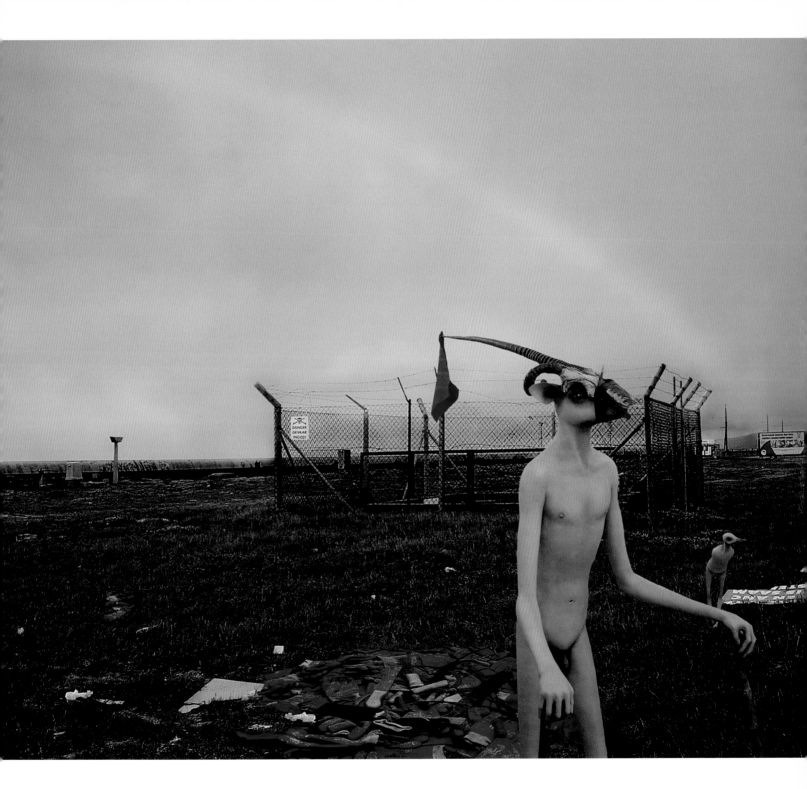

Me and the Buddhists, 2005
Watercolor
64 × 54 inches

Santiago Cucullu

Me and the Buddhists was originally derived from a three-dimensional metal sculpture. It is to be interpreted as the interaction between two or more people. Cucullu also compares the artwork to two political symbols of resistance—the "sub-commandant Marcos and the Dalai Lama."

"In a world where the only possibility for survival lies in our similarity to one another, we are left with two figures that must transcend the idea of the individual ego and its position as a catalyst for change. We must create a society where our reliance on one another grows when we move ahead."

Dario Campanile

La Pace E Con Noi (Peace Is With Us), 2005
Oil on canvas
36 × 36 inches

"The idea that wild things can be tamed, that complicated things can be made simple, that dreams can become real, and that men and women can live in harmony fills my mind with endless images."

Tom Nakashima

Tenzin Gyatso offers George Bush counsel on the war in Iraq by conveying to him the story of Yamantaka (Destroyer of Death):

"A yogi meditating in his cave had arrived at a crucial point, just minutes from enlightenment. As it happened, a rude group of cattle thieves had just stolen a buffalo and began dragging it into the cave. As they started butchering the animal the yogi's meditation was disturbed. Upon seeing the yogi, the intruders attacked and cut off his head, for he had been witness to their evildoing. Now the yogi (having been disturbed when he was just fifteen minutes from enlightenment) was indeed angered. In a fury he reached down in search of his head and mistakenly placed the buffalo head upon his neck, giving him a terribly ferocious appearance not unlike Lord Yama (the god of death). He took the knife from the robbers and hacked them into pieces. Then, running out into the countryside, he headed toward a village with his arms flailing and the sound of a buffalo's sickening snorting emanating from his throat and nostrils. At this frightful sight the villagers called forth to the Bodhisattva Manjushri (or Jampel Yang) to save them. In response, Jampel Yang turned himself into Yamantaka—a virtual mirror of the approaching horror. On seeing the absurdity of his actions, the yogi (in utter embarrassment) ceased his rampage and returned to the cave."

In His Ultimate Compassion, His Holiness
the 14th Dalai Lama Manifests Himself, 2005
Torn newspaper collage, glue paint
96 × 72 inches

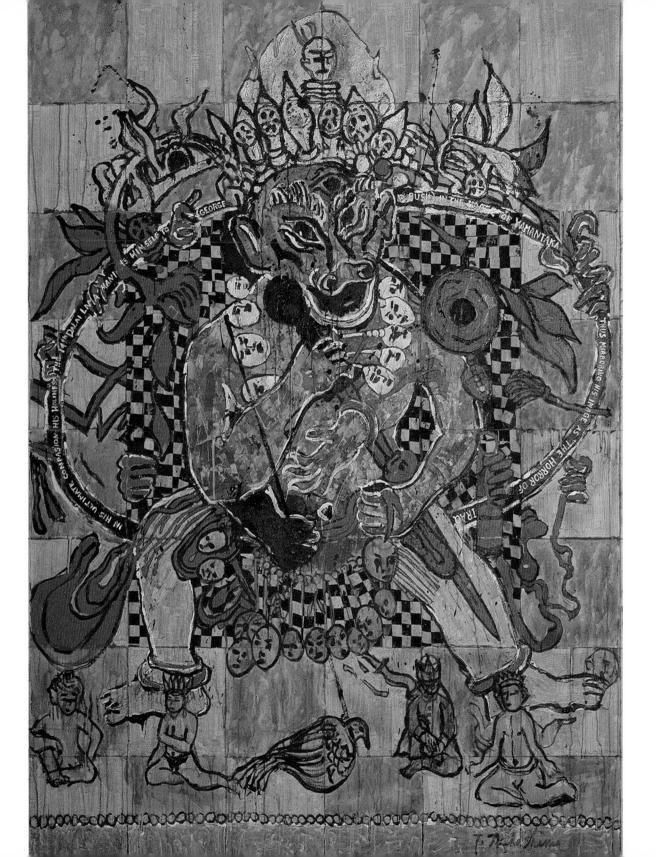

*Luz y Solidaridad
(Light and Solidarity)*, 2006
Mixed media installation
Dimensions vary

Susan Plum

"In the past decade, almost one thousand women and girls have been killed or have disappeared in Juarez, Mexico, across the border from El Paso, Texas. Many of the victims were raped, mutilated, and tortured. Despite the fact that these murders have persisted for so long, there has not been significant progress in providing protection to the women of Juarez or in bringing the perpetrators to justice.

Tenzing Rigdol

A Man Following a Tail, 2003
Acrylic on canvas
41 × 62 inches

This painting is an exploration of ideas of violence and war. The artist presents his view of the stages of war and how one can unknowingly be lured into the violent actions. The painting is also a response to the recent war against Iraq and hybridizes the contemporary issues of nonviolence with the teaching of many ancient and contemporary masters such as the Dalai Lama, J. Krishnamurti, Jesus, and Gautama Buddha.

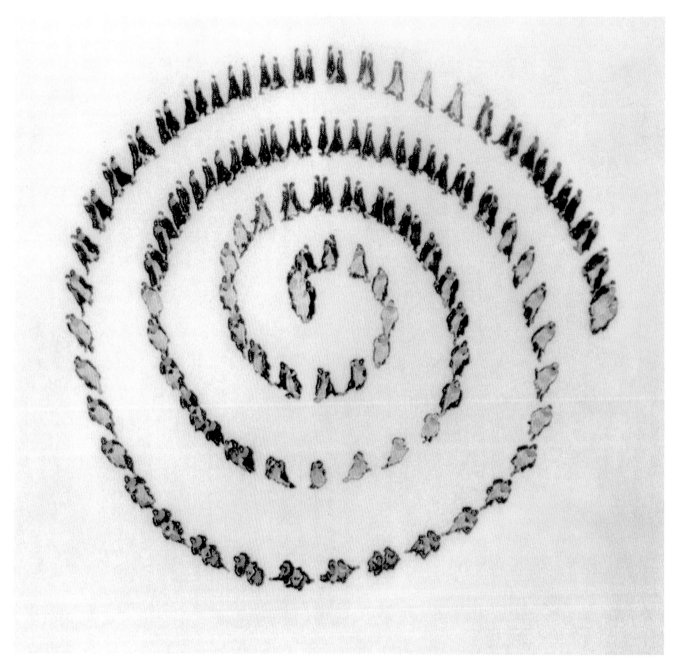

Michal Rovner

Spiral-Link, 2004
Pure pigment on canvas
37 1/2 × 37 inches

Spiral-Link demonstrates action, co-action, interaction, and re-action. The labyrinth painting has to do with the chain of exchanges between people.

Rosemary Rawcliffe

Reclamation, 2006
Video
3 minutes

The Dalai Lama says, "everywhere we are talking, constantly about peaceful humanity, a peaceful world. This is not from prayer, not from technology, not from money, not from religion, but from Mother. This is my fundamental belief. Mother, I consider our first teacher, teaching compassion."

For Rawcliffe, a healthy family means healthy humanity. The mother plays a key role in the creation of world peace. Working with the Dalai Lama and poetry by Louis MacNiece provided inspiration for the artwork.

Web/Transient #2, 2005
Cast resin
66 × 54 × 4 inches

Yuriko Yamaguchi

"The piece titled *Web/Transient* is about conflict and struggle, like that of prey caught by a spider's web. Viewers of this artwork can find brains, hands, toes, body parts, unidentifiable objects, and divided houses tied by a web of wires. They represent the current reality. How people read or interpret this is up to the viewers. I am concerned about how, in a way, we are divided nations and divided communities, even if we are not happy to accept it. I am not advocating the division; rather I prefer to have peace on Earth."

Abu Ghraib, 2005
Painting on canvas
5 × 4 feet

Rupert Garcia

Garcia's painting records the horrific and much-publicized scandal of Abu Ghraib prison in Iraq. It is based on one of a series of photos, taken by U.S. soldiers, of Iraqi prisoners being tortured by the U.S. military at the prison. The hooded prisoner had wires attached to both hands and other body parts, and was reportedly told he would be electrocuted if he fell off the box on which he was standing.

8

UNITY

ARTISTS:

Marina Abramovic

Long-Bin Chen

Kirsten Bahrs Janssen

Seyed Alavi

Christo & Jeanne-Claude

Arlene Shechet

Robert & Shana ParkeHarrison

Constantino Ciervo

Michele Oka Doner

"Today, more than ever before, life must be characterized by a sense of universal responsibility, not only nation to nation and human to human, but also human to other forms of life."

—THE DALAI LAMA

SCIENTISTS TELL US THAT IF a human body were to be fully condensed, the remaining matter would be the size of a pea. That matter is made up of the same fundamental building blocks that compose all other earthly phenomena—the animal realm, the oceans, the air. This points to our basic oneness and the interconnectedness of all life on earth. Many world religions urge us to see the benefit of unity and to realize that we all come from the same source, yet we cling to our feelings of individuality and superiority.

Developing respect for our similarities and acknowledging our interdependence leads directly to peaceful action. When we think of ourselves as belonging to a single, unified world, we can look for solutions that address the larger whole, not just one small part. It is not easy to let go of allegiances, biases, and self-interests, but the notion that one side is right and good and the other side is wrong and evil sets us up for failure. The Dalai Lama teaches us to search for the common suffering and to find a common peace within it.

Jeff Greenwald

do aliens have a buddha nature?

I T BEGAN WITH A RUMOR, as so many things do.

In the early 1990's, I'd heard, the *Los Angeles Times Magazine* had published a photograph showing the Dalai Lama on the set of the starship *Enterprise*, posing with Data, the program's high-spirited android.

The Dalai Lama a "Trekkie"? Astounding, but possibly true. I already knew that the 64-year-old Tibetan Buddhist monk takes an active interest in particle physics. I was aware that he'd met with neurosurgeons, mathematicians, and astronomers, exploring the tantalizing territory where Eastern mysticism meets Western science.

I searched in vain for the photograph. Though my contacts at Paramount confirmed its existence, no one could remember exactly when, or even where, it had appeared. Several maddening months went by before a sympathetic *Voyager* staffer unearthed the studio's copy of the original slide and sent it to me by FedEx.

It was not quite as advertised, but it was close. The snapshot was taken in 1990 or '91, when His Holiness and his retinue had toured the western United States. In the picture, nearly two dozen monks from the Namgyal Monastery in McLeod Ganj, India (where the Dalai Lama now lives) are crowded onto the *Enterprise's* transporter pad, surrounding the pale-faced

Data. The Dalai Lama himself is not present, but many of his most important attendants—including his ritual master, Tenzin Dakpa Tashi—are. His Holiness, I deduced, might also be a fan, even if his hectic schedule had made a visit to the set impossible.

McLeod Ganj is a world apart from the truck-breath, deafening diesel realm of New Delhi. There are birds tweeting, kids laughing, and the percussive splash of slop buckets emptying from overhead windows. Along muddy thoroughfares, stray cows and squatting vegetable wallahs face each other in a delicate truce. Eight-year-old monks cluster around the doors of darkened video theaters, gawking at the latest Jackie Chan and Jean-Claude Van Damme movies.

The morning of my interview I hike to a waterfall, several kilometers up a dirt road. It's good to be away from the hubbub of town, in a place where the sky is not subdivided by power lines. A dozen monks wash their clothes in the river; the yellow and vermillion of their robes are handsomely photogenic against the stones. I think to myself: Having an audience with the Dalai Lama and asking him about *Star Trek* is like meeting the Buddha and asking him to recommend a good Indian restaurant.

A fifteen minute walk down the main drag leads to the Namgyal complex, which shelters the residence of His Holiness. After much paperwork and an intimate body search, I'm escorted to the house itself. It is pale yellow, almost institutional in architecture; a far cry from the Potala. Inside, the air is chilly. The walls are cluttered with medals, citations, and honorary degrees.

Despite his many honors, Tenzin Gyatso—the Fourteenth Dalai Lama—is a man without airs. He describes himself as a "simple Buddhist monk," whose most cherished wish is to live a life of retreat and meditation. That's not going to happen. As the most eloquent and charismatic spokesman for the Tibetan diaspora, he is continually besieged by requests for audiences and interviews, while his responsibilities as a spiritual leader occupy the remainder of his time.

Ten minutes later I'm led through French doors and into the audience room. Here it is warmer, and there are couches arrayed beneath a large altar. I sit down, setting my notebook on a low table. Then I rise abruptly, for His Holiness is being escorted into the room.

The Dalai Lama appears fit and alert. His eyes are welcoming, curious, and brightly amused. It's been perhaps a week since he last shaved his head, and the stubble on his scalp shows less gray than I would have thought. Though he tends to stoop—out of humility, I suppose—he is tall and big-boned, born in the rough-and-tumble landscape of northeastern Tibet.

But this is merely his outward appearance. Far more profound is the effect of his personality. The cynical tongue is stilled: here is The Loveliest Man in the World. His humility, wisdom, and kindness illuminate the room like halogen bulbs. Offering him the traditional greeting of a kata—a white silk scarf—I nearly giggle with pleasure.

I ask the Dalai Lama if moving toward the stars—to "seek out new life and new civilizations"—is humanity's destiny. He raises his eyebrows.

"I don't know," he replies. "I don't think that it's humanity's destiny. No harm, to try to reach those areas and settle—but it is quite certain that the whole world cannot shift there. In any case, our planet, this planet, will always be humanity's home."

"What does Tibetan Buddhism say about the possibility of life on other worlds?"

"Sentient forms of life—similar to human beings—do exist on other planets," the Dalai Lama replies. "Not necessarily in our solar system, or even in our universe, but beyond."

"Do you believe this," I ask, "or do you know this?"

"Believe." He answers without hesitation. "So far, I haven't met any person who recalls a previous life from another galaxy." Still, he insists, such beings doubtless exist—probably with five sense organs and emotional capabilities similar to our own. All will be capable of suffering and compassion; all will be responsive to kindness or cruelty.

"According to both Western cosmology and Tibetan Buddhism," I say, "everything in the universe was created from the same microcosmic particles. So would extraterrestrials be subject to the laws of karma and reincarnation?"

"Yes! Yes! Maybe, I think, they will have a different form. But generally speaking, the same laws. Perhaps," he adds thoughtfully, "some differences in dealing with anger and other negative emotions. But basically, the same."

But our meetings with these ETs, the Dalai Lama warns, must be motivated by good intentions. "Do we find a new neighbor? Make a new friend? Then, positive!" he declares. "But find a new neighbor, create problems, and fight—then, more suffering! If our planet is not a stable, compassionate world, even if we meet someone out there, it will only create an additional enemy. If we use the same intentions as we do here—conquer, exploit—well, they're sentient beings, too! They also have ideas that are selfish! They will retaliate! But if we cultivate a nonviolent approach and visit with a warm heart—good!" He leans forward, slapping me powerfully on the knee.

"If Your Holiness were given the opportunity to orbit the Earth in the Space Shuttle," I inquire, "would you accept?"

There is a moment's silence. The Dalai Lama stares at me with wide eyes before replying. "If very safe—then I will go!" He laughs uproariously, and wipes his eyes on the sleeve of his robe.

"Is this a dream of yours? To view the Earth from orbit?"

"Interesting . . ." he nods, considering the question seriously. "But not essential. Still much work to be done here, on this Earth. Until there is no poverty, no illness. Once everything is okay on this planet—no further problems—then we'll need a holiday!"

I steel myself, and ask the Dalai Lama about *Star Trek*. Has His Holiness ever watched the show on Indian television? Indeed he has, but only the original series. He recalls with hilarity the "man with the big ears": Spock.

The previous day I'd met with Tenzin Dakpa Tashi, the Ritual Master who appears in the snapshot taken while the Namgyal monks were touring Paramount Pictures. Tashi had proposed that the people who write *Star Trek* might unconsciously be anticipating Shambala: a peaceful, ideal realm that, according to Buddhist texts, will emerge on Earth several centuries in the future. He'd raised a compelling point. The defining features of Roddenberry's world—goodwill among all beings, a peaceful planet, and the

ability to explore the galaxy with our best foot forward—are very similar to Tashi's description of a mythical Buddhist utopia.

"Your Holiness," I ask, "Do you believe that our space-faring future, as portrayed in the *Star Trek* programs, may be a vision of Shambala?"

He considers the question for a moment. Then he crouches back in his chair and mimes aiming a phaser—*Star Trek*'s signature ray gun—at me. "Even in the future, many unique weapons!" The Dalai Lama grins impishly. "So not much different than now, I think!"

Inspired by the slide of the Namgyal monks surrounding Data, I ask about artificial intelligence. The British mathematician and logician Alan Turing, I explain, developed a famous test to determine whether or not a computer could be considered conscious. In his "Turing Test," a computer and a human subject are concealed in separate rooms. An interrogator asks questions of both via a terminal, not knowing which is which. If the questioner cannot tell, from the replies, which respondent is human and which is a machine, the computer has "passed."

I ask if the Dalai Lama has a similar test, one which would enable him to decide to his own satisfaction whether or not a machine or robot possessed consciousness.

"If a machine acts like a sentient being," he replies, "I think that it should be considered a sentient being. A new kind of sentient being." Words are not enough; in the Buddhist belief system, the force generated by one's actions—their karma—is crucial. Still, His Holiness says, Buddhist scriptures speak of different ways of taking birth in this world. The traditional way is through the womb; but other means are also possible. These might be through chemical or even electrical processes. If conscious computers are developed, they will deserve the same respect we give to sentient beings.

Star Trek, of course, assumes a very cozy relationship between humans and technology. Does His Holiness find this an alarming vision? Is it possible, on general principle, for reliance upon technology to exceed healthy limits?

The Dalai Lama leans forward, regarding me mischievously. "If a machine is ever created that can instantly make a good heart, a warm heart," he pronounces, "without any need for meditation or

practice . . ." He falls back in his chair, laughing. "Then I will imme-
diately tell our Chinese brothers and sisters: 'Please! You buy this!'"

I had expected the Dalai Lama to come down on one side
or another of these issues. But the common thread in his respons-
es, I'm discovering, is the expansive view that technology itself is
neither good nor evil. Even his reply to my comments about the
Internet, and the plague of information addiction that seems to be
sweeping the globe, surprises me.

"One aspect of Buddhahood," he reminds me, "is omni-
science. The gathering of information is neither good nor bad. In
this case—and in all cases—everything depends upon intention. It
is always a matter of motivation, and result. So long as there is no
harm to others, then I think, okay!"

The final question on my notepad is so absurd that I'm
worried it might offend him. So far, though, my venerable host has
shown only the best humor. I take the plunge. "You've been quoted
as saying," I begin, "that, depending on the view of the Tibetan
people, you may be 'the last Dalai Lama.' Here's a twist on that
issue. Through the science of cloning, it may be possible—in the
near future—to take some DNA from Your Holiness, and use it
to create potentially endless reproductions of yourself. If this were
done, you could literally be the last Dalai Lama—for centuries to
come. What do you think of that?"

The monk and his attendants laugh so loudly that the
needles on my tape recorder leap off the scale.

"You can reproduce my physical body," the Dalai Lama
quips at last. "But this mind?" He taps his skull, the mythic reposi-
tory of countless lifetimes. "I don't think so!" ☙

(An excerpt from *Future Perfect: How Star Trek Conquered
Planet Earth*)

John Perkins

the dalai lama, indigenous shamans, art, and the unity of all things

I SAT NEXT TO THE DALAI LAMA on a flight from Ladakh, across the Himalayas, and into India, in 1999. I found myself in this enviable position due to a series of "coincidences" and the fact that the Dalai Lama is interested in Amazonian cultures. On his lap was a copy of my book, *Shapeshifting*.

We talked at length about indigenous people and their relationship to the world around them. I explained to him about how I was taught to "walk without watching my feet" by the Shuar who live deep in the Amazon rain forest. In their environment it is essential that people observe all that is going on around them. The men, who carry long blowguns across their shoulders, are constantly on the lookout for birds and other animals they can take home as food for the family. The women are always searching for plants they can use in cooking or for medicinal purposes. Everyone—men, women, and children—is vigilant; their very survival depends on their ability to be totally attuned to their environment.

"The Shuar," I said, as we peered through the plane's window at the glacier-covered mountain peaks below, "teach that our feet are basically boring; we need to open our hearts, as well as our sight and other senses, to every step we take. When we forget to do this, we miss the joy of truly living."

The Dalai Lama mentioned that he thought this teaching of the Shuar was applicable to all aspects of life. "It is the same as the best of the Buddhist teachings," he observed. Then he asked me to talk about the role of the shaman in indigenous cultures.

"One of the greatest responsibilities of the shaman is to help people stay connected with their environment," I said. "Shamans show the way to honor the interrelationship between all things."

"Like art," he said.

It stopped me short, but I realized that he was right, that the function of much of our art is similar to that of the shaman. The best art helps us understand and feel the unity of all things; it brings together the mind and heart, and uplifts the spirit.

After that we discussed the disconnect experienced by many people in "modern" societies, the focus on the latest fashions, the ranking of a favorite sports team, the personal lives of celebrities, and other issues that have little to do with being fully present, or with our long-term survival. "This is the equivalent," I concluded, "to watching our feet."

The Dalai Lama nodded his agreement. "It is time for us all to learn to walk without watching our feet," he said, and then he laughed. "I may stumble a few times, but I surely will take the teachings of your Shuar friends to heart the next time I go for a walk."

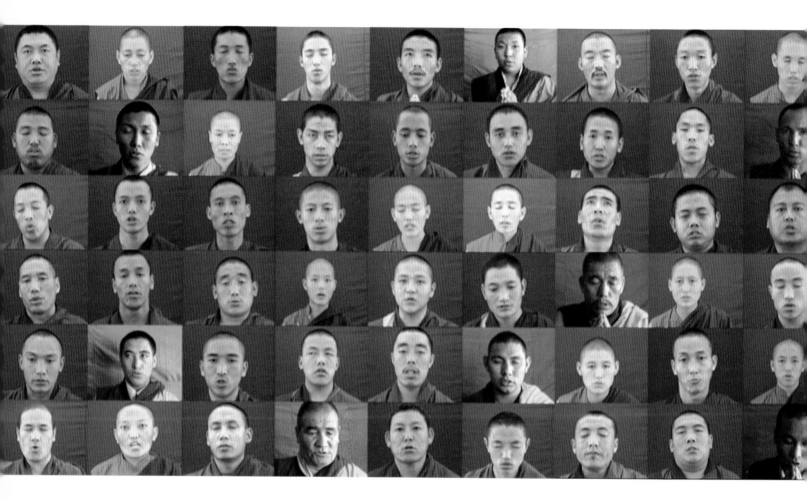

Marina Abramovic

"After twenty years of visiting Tibetan monasteries in India, the director of Tibet
House in Delhi asked me if I would be a choreographer for Tibetan lama dancing
and chanting. I was supposed to compress the performance into one hour and twenty
minutes, without losing its essence. I ended up working in the monastery with 120
monks, using a megaphone to teach them how to come on stage, go off stage, remem-
ber the positions of the lights, how to change their elaborate costumes in less than
thirty seconds, etc. I decided to project all 120 videos simultaneously on a large wall.
Then I was hit with a realization: when you hear all the prayers from the different
monasteries and traditions at the same time, they sound like a huge waterfall."

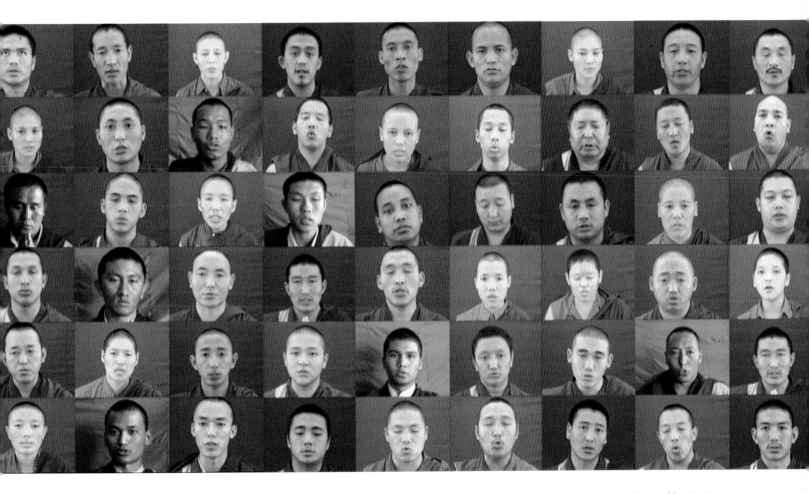

At the Waterfall, 2000-2003
Continuous video loop projection
11 × 45 feet

World Buddha Head Project, 2005
Recycled phone books
42 × 20 × 20 inches

Long-Bin Chen

In Buddhism, all sentient beings—human and animal—are regarded as having a Buddha seed. Buddhism teaches that when we die, the mind, with all the many characteristics developed and conditioned in this life, re-establishes itself in a fertilized egg. Similarly, the genes carried in DNA are passed on from generation to generation.

In this work Chen explores the relationship between Buddhism and DNA structure. Comprised of printed matter, which the artist sees as the cultural debris of our information society, this work reveals three sculpted sides with the faces of Buddha, an animal, and a human, each revolving around another.

Kirsten Bahrs Janssen

The Golden Thread, 2006
Mixed media
60 × 60 × 26 inches

Through touch and physical interaction, the viewers physically link their arms around the world, connected by a single golden thread.

Seyed Alavi

Alavi's work engages the poetics of language and space and their power to shape reality. This conceptual work invariably springs from wordplay and symbolism. Alavi states that language is another medium, such as paint and clay. Each artwork is intended to be read as a sign, a new visual language, asking us to reflect on issues surrounding the nature of our lives, our interactions with each other, and our connection with the world at large.

Sign of the Times, 2006
16 digital prints, wood, canvas
60 ×96 inches

The Gates Project for Central Park, 1979–2005
Collage and C-print
12 × 30 ¹/₂ inches, 26 ¹/₄ × 30 ¹/₂ inches

Christo & Jeanne-Claude

After Michael R. Bloomberg, Mayor of New York City, announced on January 22, 2003, that a contract had been signed permitting New York artists Christo and Jeanne-Claude to realize their temporary work of art: *The Gates, Central Park, New York, 1979–2005*, the fabrication of all the materials began. The installation at the site in Central Park was completed with the blooming of 7,500 fabric panels on February 12, 2005.

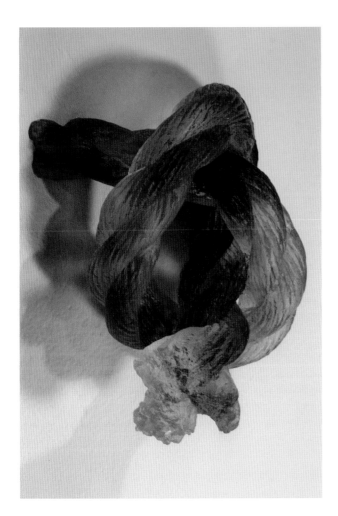

Out of the Blue Series: EXCHANGE, 2004–2005
Cast crystals sculpture installation
73 × 120 × 12 inches

Arlene Shechet

"It's an open conversation.
Like crystal, all conversations are precious and fragile.
I think of His Holiness creating connections, openings, pauses, awareness.
Honoring the dialogue without attachment."

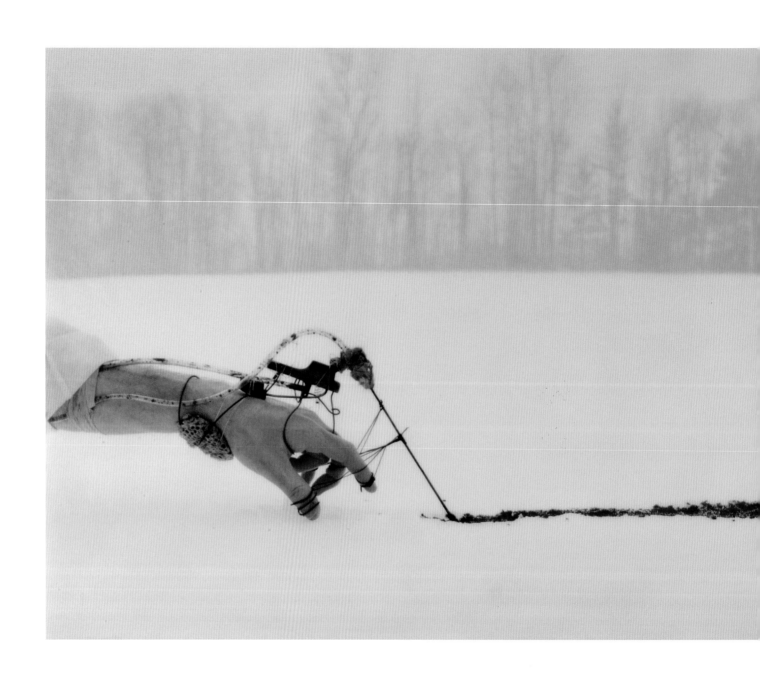

Robert & Shana ParkeHarrison

There is the paradox of being human; in order to survive we must destroy. This paradoxical issue is represented in the destruction of the earth and our continued process of transforming and destroying nature. We are interested in the rediscovery of our lost relation to nature. Through the actions of ritual in our photographs we are able to explore these issues. We create and control entire scenes and freely manufacture metaphor, re-examine myths, and perform ritualistic acts.

The Scribe, 2005
Chromogenic print on
aluminum with acrylic
40 × 85 inches

Constantino Ciervo

Who Am I?, 2004
Looped DVD

The video portrays the disconnect many people feel to our natural environment as the earth below moves in different directions, making it difficult to remain grounded.

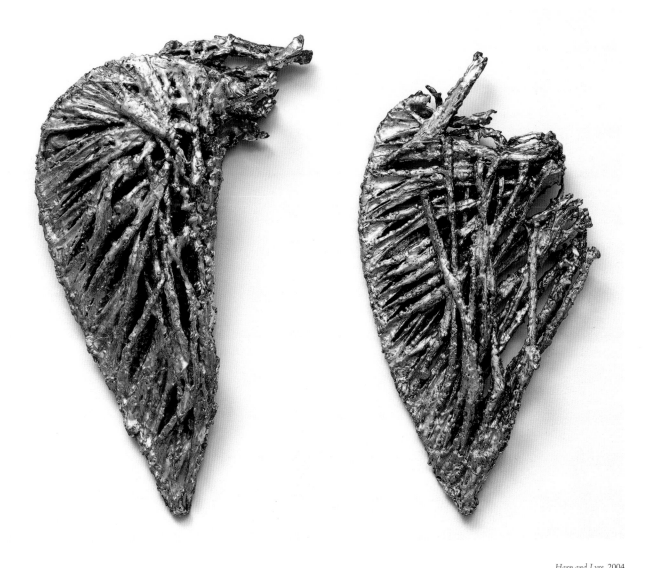

Michele Oka Doner

Harp and Lyre, 2004
Cast bronze with gold leaf
22 × 13 × 5 inches

"If mythology were to be described as a public dream, a collective venture of the imagination, then art could similarly be defined as a form of dreaming out loud, to probe the cosmos, express the ineffable, lend order to life, and reconcile us to our fate."

Aptly called "nature's scribe," Oka Doner defines her task as materializing the ephemeral by using organic forms as her vocabulary. Created from cast bronze palm leaves, the lyre represents the underlying harmony of the universe, and the harp represents ascendance leading us into the next world.

9

SPIRITUALITY AND GLOBALIZATION

ARTISTS:

Yoko Inoue

Inkie Whang

Sanford Biggers

El Anatsui

Squeak Carnwath

William Wiley

"The world is becoming increasingly interdependent. We need to think in global terms."

—THE DALAI LAMA

THE DALAI LAMA ACKNOWLEDGES that science and technology have brought much benefit to the world. To science we owe the miracle of space travel, the eradication of diseases, and remarkable discoveries about brain chemistry. He warns, however, that modernization has also had a devastating effect on our environment, our health, and our human rights. There is often a hidden cost to the many modern conveniences that those who can afford them enjoy. His Holiness urges us to develop our spiritual and material worlds in tandem. As it is, devotion to the commercial world has all but replaced old forms of worship. Instead we worship at the altar of the marketplace becoming imprisoned by it as we continue to lose touch with our true spirituality.

Underlying each war—whether man against man, man against nature, or man against time—is a struggle against one's true nature, what the Dalai Lama calls "Buddhanature." Everyone has this nature, this light. And since each human being matters, each has an effect on the others. Interdependence is a law of nature, and until it is acknowledged, the gap between haves and have-nots will only grow wider, and globalization will collapse unto itself.

Lilly Wei

only connect

RUDYARD KIPLING, the spokesman for the Raj, once said that East is East and West is West and never the twain shall meet. But times have changed. Kipling's words came before the internet, cell phones, flights to almost anywhere in the world in under twenty-four hours, the proliferation of centers of exchange, the creation of self-determining postcolonial political systems, and the rising economies of Asia and other developing regions. Culture, too, both high and low, is on the move and art, its ambassador, is ever more easily disseminated by means of new technologies. Inevitably, a discourse of diversity and inclusion has evolved. Artists are also increasingly nomadic, and an art without borders—cross-pollinated and hybridized—is the new norm, reflecting a world that has become ever more exultantly globalized. This does not mean homogenized, as antiglobalists and isolationists would have it. Ultimately, we must think in global terms; there is no other choice.

This kind of exchange is not new, of course, but it is accelerating and the direction of appropriation and influence can no longer be perceived as a one-way street, from west to east, and north to south. Even when the direction was reversed as, for instance, when Vincent van Gogh used Japanese woodblock prints as models for his work, Franz Kline, calligraphy, or John Cage, the I Ching, their borrowings were considered innovative in the eyes of their Western audi-

ence. However, when Asian and African artists riffed on Western motifs and styles, the same viewers dismissed their interpretations as derivative, although from a non-Western point of view the work was equally avant-garde. One thing, however, is certain. The rest of the world no longer exists in a purely dialectical relationship to the West based on Western terms, with all its misconceptions, filtered through insufficient knowledge, disregard, and the distorting lens of denigration and exoticism, fear and desire. These days Western studies heed more closely the representation of other countries as interpreted by their own artists, writers, and thinkers rather than exclusively through Western commentaries. Consequently, contemporary discourse is more global, more informed, open-minded, multidimensional, and sensitive to cultural differences—and similarities. One result of such interconnections and mass migrations is a more expansive, eclectic, and idiosyncratic field for culture and for human relationships. As noted by Salman Rushdie (although where Rushdie says "people," we might substitute "artists" for the purposes of this discussion) in Imaginary Homelands, people are "radically new types of human beings: people who root themselves in ideas rather than in places, in memories as much as in material things; people who have been obliged to define themselves—because they are so defined by others—by their otherness; people whose deepest selves fuse together."

With its compassionate acceptance of ordinary human existence, Buddhism offers an antidote to our increasingly materialistic, narcissistic, and aggressive culture and a compelling alternative to Judeo-Christian and Muslim precepts. Many artists have found solace, healing, and beauty in Buddhism's principles and all-encompassing view of the world—of being in it—that has proved infinitely fruitful for both their life and art. The works in this exhibition give us a glimpse of how contemporary art inspired by Buddhism can look and how it can be experienced.

Some artists draw directly from the rich legacy of traditional Buddhist iconography and rituals, although these images are presented within the syntax of contemporary aesthetics and rely on a variety of contemporary media such as video, the Internet, performance, and installation as well as painting, drawing, sculpture, and photography. Other artists are less overtly linked to a Buddhist tradition and should not be considered solely within the context of Buddhist formulations. Their work, often abstract or nonobjective, meditative or ephemeral, also constitutes a part of the history of modern, postmodern, and contemporary art that has been informed by Buddhism, directly or indirectly, since at least the late-nineteenth century but especially in the aftermath of World War II. Many reflect the influence of the writings and teaching of D. T. Suzuki, who introduced or further explicated Zen Buddhism to several generations of Americans and Europeans, including Thomas Merton, Aldous Huxley, John Cage, Jack Kerouac, and their followers. Many reflect the teachings of the Dalai Lama. Some of the works in this exhibition, then, are based on Buddhist iconography, while others are based on the Buddhist spirit. Some of these works might be considered Buddhist because they reflect the intent of their creators, who are practicing Buddhists, while other participating artists are not Buddhists but have been profoundly influenced by Buddhism and have dedicated works to Buddhist philosophies and imagery.

There is, of course, no fixed style or content in contemporary Buddhist art, as there is none in contemporary art. It can be abstract, representational, and conceptual. It can be symbolic and concrete, profound and humorous, meditative and raucous, fierce and mild, ethereal and earthy, even bawdy. It can be empty and full and it can be all of this simultaneously, merging opposites into an intricate sense of totality. It might be thought of as artlessness transformed into art, as a series of processes as well as objects. Buddhism invites us to see the world directly, without mediation, to regain our original spontaneity, and to reconcile opposites in moments of "mindful awareness." Buddhist scriptures emphasize knowledge other than that which is quantifiable and ways of thinking that are resistant to intellectual analysis: Buddhist art does the same. Much like Buddhist art—perhaps all art—Buddhism explores the peripheries of the mind rather than its ratiocinative centers. Indeed, Buddhist paradoxes and conundrums—often baffling or exasperating to Western minds—as well as Buddhist ambiguities and relativism, lend themselves particularly well to

artistic practices and theories. Like art itself, Buddhism has no absolute definition, is more fluid, more exportable and absorptive than other systems of thought. It is not a religion or a philosophy, a psychology or a science, and it comes in many flavors, including Indian, Chinese, Japanese, Korean, Tibetan, that of the countries of Southeast Asia and the Himalayas, and now, possibly, even American. According to Zen scholar and interpreter Alan Watts, Buddhism is most aptly described as a "way of liberation," "the finger pointing to the moon, not the moon itself."

A classic instruction to an aspiring Buddhist calligrapher/painter is that he must learn to let the brush draw by itself. This, he is told, cannot be achieved without practice, but it also cannot be achieved with practice. Buddhist art aims for both detachment and attentiveness, for a childlike spontaneity and an ancient wisdom. It also aims, both effortlessly and with effort, for transcendence and transformation. To consider, then, the artist involved with Buddhism and his or her role in creating works that shift public perception, to think of spirituality as a commodity, global or otherwise, seems rather anomalous. What occurs in this kind of art is more subtle, less visible, less quantifiable. It is experiential, rooted in the spirit, in personal encounter and transformation on the part of the viewer, and is essentially private. Yet upon further reflection, by means of connection, in the sense of Mahayana Buddhism's notion of tantra (thread), which refers to the interdependence of all things, in which the individual is part of the community and the community is part of the world, these works of art—like the flap of a butterfly's wing that sets off a hurricane—do have public consequence and do change the world profoundly.

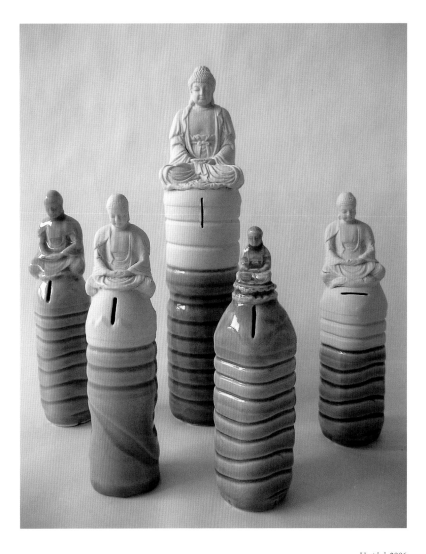

Untitled, 2006
Mixed media video
Dimensions vary

Yoko Inoue

In the form of an installation, Inoue's work explores the amorphous border between commodity and spirituality. Through the forces of economic globalization everything seems to be for sale, even natural resources like water, once considered a common heritage and sacred. Inoue explores the historical relationships between people and everyday domestic objects, which she finds most prevalent in the transient cross-cultural merging of the urban street market. Her installations of mundane objects create a space of meditative, temple-like serenity. Inoue examines the interface of spiritual purity and commercial corruption. In past installations, she has hand-cast porcelain replicas of new or discarded domestic objects.

Inkie Whang

Temple at Night, 2004
Pixelated silicone on canvas
28 1/2 × 71 inches

Trained as a painter in both the United States and Korea, Whang describes his art as "digital sansuhwa," a reinvention of traditional Korean ink and brush landscape painting using new technologies. His artworks are "digitized landscapes that illustrate the models of assimilation and transformation of nature in the context of our modern materialist and technology-driven civilization."

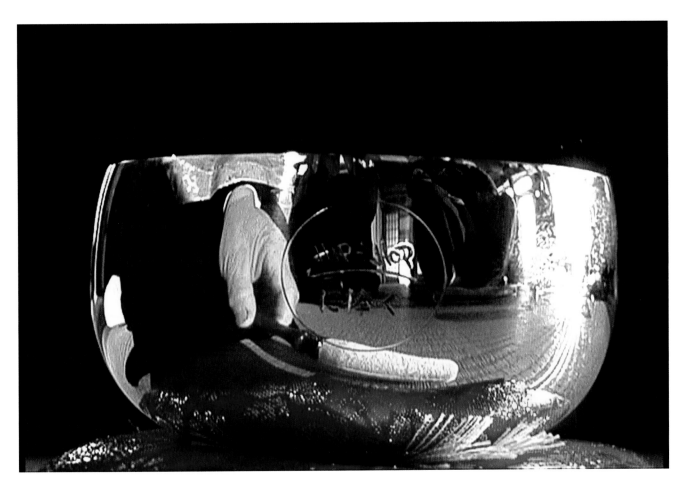

Sanford Biggers

Hip-Hop Ni Sasagu
(In Fond Memory of Hip-Hop), 2003–2004
Mixed media, video
25 minutes
Mori Bell, 5 × 5 × 5 inches

The video documents the original bell ceremony conducted by the artist at the Joanin Soto Zen Temple in Moriya City, Japan. The bells used in the ceremony were fabricated by the artist and the Mori Company in Tokyo. The bells are made from melted hip-hop jewelry as an "homage to hip-hop past, and the distillation of the 'bling-bling' culture into a vessel capable of sound, but only if struck correctly and with reverence."

El Anatsui

El Anatsui tapestry serves as a reminder of temporality and decay. Thousands of discarded bottle caps are sewn with copper wire into monumental cloth hangings. Anatsui weaves the debris of consumerist excess into a glittering textile in the long tradition of West African textile production, subverting notions of tradition and modernity, and prompting us to reexamine what makes up the very fabric of our lives.

Dzensi, 2006
Aluminum and copper wire tapestry
11 ¹/₂ × 13 feet

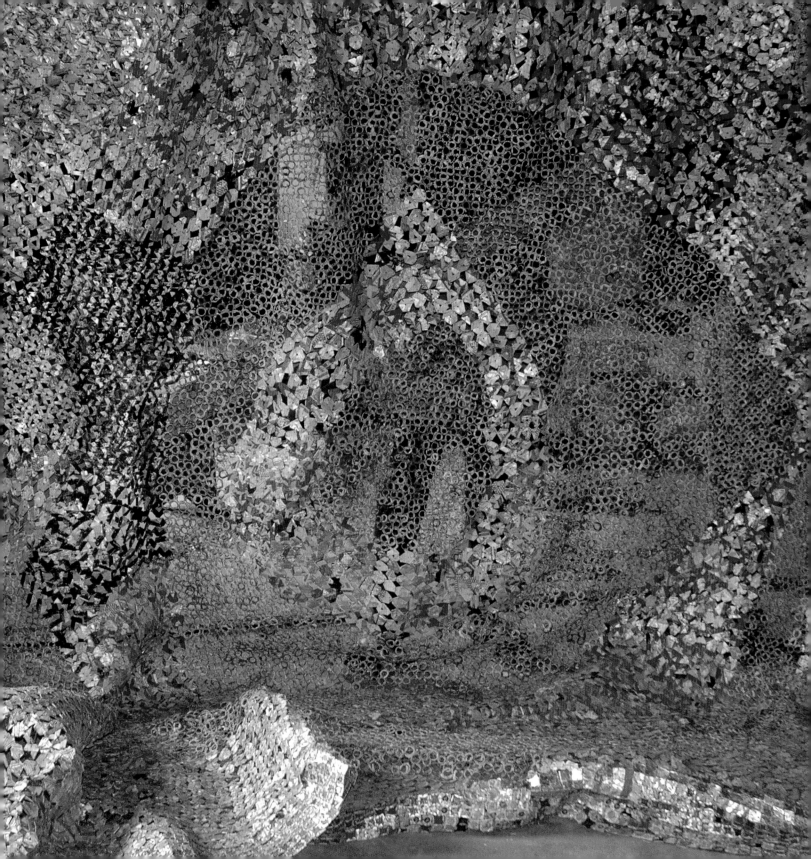

Squeak Carnwath

Carnwath's often large-scale, luminous paintings investigate the act of living. She explores the repetition of our daily routines and actions, like a phonograph record spinning round—we wake up, go to our jobs, eat, and breathe. Carnwath does this exploration through observation and enumeration. "Art is evidence," she says, "evidence of breathing in and breathing out, proof of human majesty."

Naturally We, 2005
Oil/alkyd on canvas over panel
80 × 80 inches

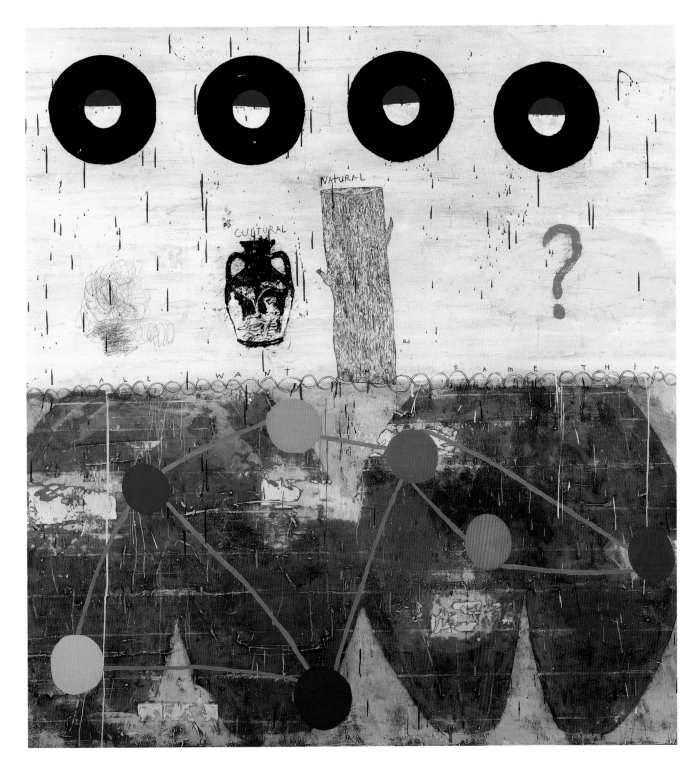

William Wiley

Within the tapestry, the snake reflects a narrow-minded figure who sees only in black and white and wears a golden mask: the golden shield of money protecting him from the colors and abstractions that might take over. He is afraid of abstract ideas. The image contrasts a shallow, greedy impulse with a more ambiguous, colorful side of human nature.

Serpent Frightened by Color,
Abstraction, and Time, 2004
Tapestry
76 × 105 inches

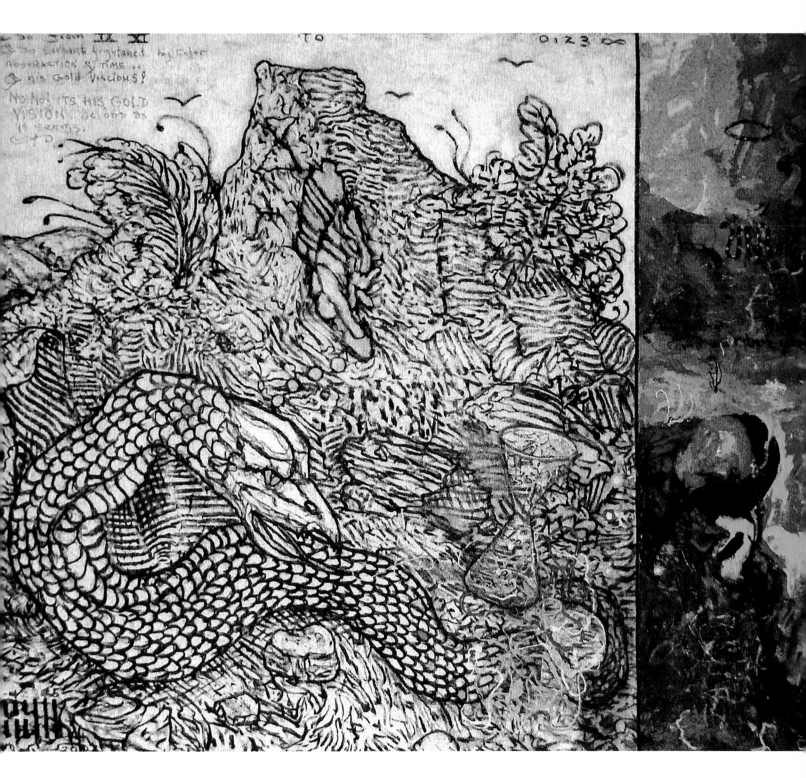

IO

IMPERMANENCE

ARTISTS:

David & Hi-Jin Hodge

Ilya & Emilia Kabakov

Pat Steir

Spencer Finch

Mike & Doug Starn

Juan Galdeano

Dove Bradshaw

" 'Momentariness' is the essential
part of impermanence—constantly
going through change, cessation,
and destruction."

—THE DALAI LAMA

IMPERMANENCE IS COMMONLY associated with the negative, with death, the end of a lucky streak, or the termination of a relationship. But this is a limited view that does not account for the necessity of impermanence and the positive beginnings that often arise from endings. Impermanence can be good news. The end of infancy is childhood, the end of war is peace, the end of loneliness is companionship. Without the end of day, we have no sunset, no moon, no stars. As Zen master Thich Nhat Hanh has remarked, "Impermanence is an instrument to help us penetrate deeply into reality and obtain liberating insight.

With impermanence, every door is open for change." Change can be scary, but it doesn't have to be. Fear arises from clinging to the status quo. When we can let go and embrace the unknown, fear subsides. Again, it is perhaps Thich Nhat Hanh who has said it best: "It is possible to find ease and grace in the world of change; it is possible to trust the mind of non-clinging and so find our liberation within the world of impermanence. As we see impermanence clearly, we see that there is nothing real that we can actually cling to."

David & Hi-Jin Hodge

time of man

"This reality of impermanence, this awareness of impermanence winds
up being almost like a torch. It comes and burns off the chaff, burns
off the debris, and leaves only that which is truly of value."

"Impermanence is the habit of letting go."

"It allows me to appreciate, to value and cherish, because it can all be gone."

"There is something beyond permanence and impermanence, and that is present."

"Something has to perish for something else to grow."

"All these conflicts in the world that seem so permanent can
be muted by changing the way we look at it."

(*Quotations from video interviews*)

Impermanence: The Time of Man, 2005–06
Multiple video iPods on stands
16 × 16 feet

David & Hi-Jin Hodge

David and Hi-Jin Hodge have recorded more than one hundred people discussing the phenomenon of change. These stories come to life on sixteen iPod stations arranged in a circle. When viewing the installation, visitors take in a wealth of experiences that invite them to recognize the impermanence of life and the peace that comes from accepting it.

Ilya & Emilia Kabakov

"The poet stands in a mountain meadow surrounded on all sides by forest: the mountains, bathed in sunlight, are visible behind the poet. In front of him is a small podium or music stand holding his work. The listeners form a semicircle at a distance of approximately thirty steps away from him. The reading begins. The poet picks up the top page and begins to read aloud. But it is impossible to make out what he is reading—the problem is the great distance between him and the listeners and the noise of the wind in the surrounding meadow. Having finished reading one page, the poet simply drops it, and it is caught by the wind and flies far away into the woods. The poet doesn't notice this and is already reading the next page of the manuscript. Finishing the last page, the poet bows and leaves. Many pages have disappeared below the mountain; some are fluttering or flying about carried by the wind. If one were to pick up one these pages, one would find that there is nothing on it at all."

The Poet, 2006
Pen and ink
31 × 40 inches

Поэт

Поэт становится на горной лужайке, со всех сторон окруженной лесом; за стволами видны горы, освещенные солнцем. Перед ним небольшая трибуна или музыкальный пюпитр, на котором лежит его произведение. На расстоянии примерно 30 шагов от него полукругом располагаются слушатели.

Чтение начинается. Поэт берет в руку верхний лист и читает то, что на нем написано. Но разобрать то, что он произносит невозможно — мешает большое расстояние до слушателей и шум ветра в окружающих поляну деревьях.

Окончив чтение одного листа, поэт выпускает его из рук и он подхваченный ветром, улетает далеко в лес, а поэт, не замечая этого читает уже следующую страницу. Дойдя до последней, поэт кланяется и уходит. Многие страницы лежат внизу, под горой, некоторые катятся или летят, несомые ветром.

Если поймать одну из этих страниц, то видно, что на теле никого нет.

/Длина перформанса 20м/

ten impermanence

153

Blue, 2005
10-color screen print, edition of 40
56 1/2 × 43 inches

Pat Steir

Steir's image of the waterfall, like a chant, evokes stillness. Over the past ten years the stillness in her work has become more dense. She makes her marks by flinging, pouring, and dripping paint. Steir has said that she makes her work with the attitude of a gymnast, "first the meditation, then the leap." In her art, she has given up chasing the self in favor of "something larger."

Spencer Finch

Sun in an Empty Room is based on the Edward Hopper painting of the same name. The viewer becomes the figure in this picture, welcomed by the startling absence of anything but light. And so it is a sort of American dream come true, to be in a Hopper painting simply by looking at one. One is sucked into this contemplative space, where the architecture serves as a screen for a light show.

Sun in an Empty Room, 2005
Watercolor on paper
52 × 114 inches

Mike & Doug Starn

"Sno6_034" from the series *"alleverythingthatisyou"*, 2006
Fujiflex and Duraclear Lambda prints
on Plexiglas and aluminum
72 × 72 inches

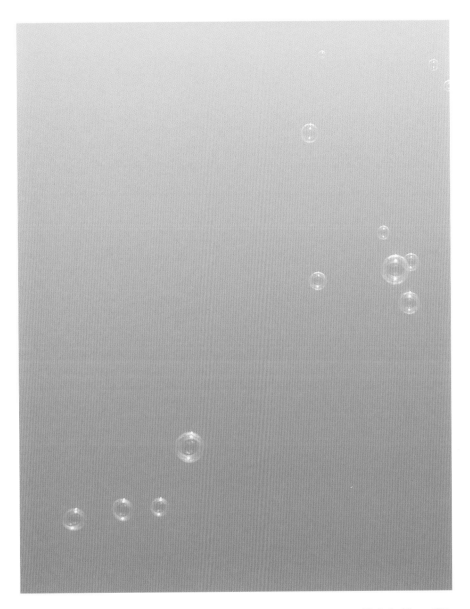

Juan Galdeano

The Perfect Moment, 2006
Bubble machine, platform
Dimensions vary

"Only in simplicity can we perceive the infinite. Let us create extraordinary art in search of true enlightenment. Let us create art that is an outburst of energy rather than a passive subject ruled by reason. Let us create art that makes sense because it is a clear demonstration of reality, art whose reality is materialized, art that transforms the arbitrary nature of beauty into beauty with a purpose. Let us see Prometheus visited by the ravens once again. How do you express the unutterable, that which does not have a name? How do you silence a language without killing it? Perhaps art is an eternal form of failure in the exhibition of the unutterable, which constitutes its main task. But perhaps this failure is more important than the task itself, or at least an integral part of it. It is the artist's responsibility to create and experience such a failure."

Dove Bradshaw

"John Cage, who had studied with D.T. Suzuki, famously fused Eastern thought with Western aesthetics. My conversations with Cage, spanning from 1977 until his death in 1992, prompted me to distance my work as much as possible from formal choices and dependence on the touch of the hand—and to more enthusiastically embrace chance. Cage told me that he did not sit in meditation but rather used chance operations as his discipline; my working discipline evolved in response to the laws of chemistry, biochemistry, geology, meteorology—and in an early work—the life of birds. Respecting the physics of these sciences lends itself to explorations beneath the surface appearance of phenomena to uncover an underlying reality in which clarity, spontaneity, simplicity, and precision coalesce".

Salt, Half-Heard, 1996–2006
1000 ml separatory funnel,
water, 100 lbs of Himalayan salt
Dimensions vary

Afterword

The search for peace

Develop the heart. Work for peace in your heart and in the world.

—The Dalai Lama

I T HAS GIVEN ME GREAT PLEASURE to present The Missing Peace: Artists Consider the Dalai Lama. For the many people who have given their time and effort to this exhibition, I hope these eighty artworks and the impact they have will be their own reward.

This project began in July 2003, as members of the board of the Committee of 100 for Tibet were searching for ways to encourage people to take positive action and improve the world around us. Through conversations with committee founder Fred Shepardson and chairman Tenzin N. Tethong, we realized that in every generation artists are the great crystallizers and amplifiers of messages. And we wondered what would happen if that power were merged with the inspirational voice of His Holiness the Dalai Lama.

Out of that idea, we decided to organize a unique exhibition featuring both established and emerging artists. Each would be invited to "portray" the full life of the Dalai Lama by creating works that would inspire us to reflect on who we are as human beings, our relationship to others, and our place in the world. For added support, we also presented the project to Tony Hoeber, the executive director of The Dalai Lama Foundation, which generously agreed to be a cosponsor.

Our ideas took a more concrete form thanks to a conversation with artist and subsequent team member Garry Bailey. We envisioned inviting fifty artists from different cultures around the world and allowing them to create works without any restriction on the size or the media that they wanted to use. We would then gather the works together in an exhibition that would tour major cities, reaching millions of people, from children to seniors alike.

But before we could move forward on the project, there was one more person we needed to consult. In the fall of 2003, members of The Dalai Lama Foundation and the Committee of 100 for Tibet presented our plan to His Holiness the Dalai Lama in San Francisco. Not surprisingly, he wanted to know why we should choose him and not someone else, and he suggested Gandhi and Mother Theresa as alternatives. The answer we gave came from the heart: we felt that our audience would be more inspired to action if our project gave them the opportunity to walk in peace with a living peacemaker.

Soon afterward, a letter came from the Office of His Holiness expressing support for our project. But it also urged us to make a small change in our plans. Rather than broadly expressing the life of the Dalai Lama, it asked us to focus instead on peace, and to encourage the artists to place it at the center of their works.

From there, the hard work began. We created a committee of twenty-five talented and dedicated people who could help us bring our vision to reality. They included specialists in law, accounting, graphic design, public relations, website development, and so on. They all agreed to donate their time and skills, and their work was vital to the success of the exhibition.

At the same time, we appointed an international steering committee for art composed of artists, critics, publicists, curators, and gallery owners. They were tasked with selecting artists from around the world who could make a positive contribution to our project.

By February 2004 we realized that we would need a dedicated curator for the project. As luck would have it, I was introduced to Randy Rosenberg, who had recently moved to the San Francisco Bay Area from Washington, D.C. where she was an independent art advisor and curator at the International Finance Corporation and the World Bank. She joined the team and eventually gathered not just fifty, but the eighty-eight artists whose works make up the exhibition.

From there, things moved rapidly. We created educational programs and solicited donations, contacted venues, and developed the criteria for the Missing Peace Compassion in Action Award, which is presented to one or more deserving individuals or organizations in every city the exhibition visits. Of course, it is impossible to list all of the people whose work went into this phase of the project, but there were many, and their contributions were all vital to our success.

And now we are at the point in our journey where we present The Missing Peace to people around the world. As visitors experience the artwork in the exhibition, in the pages of this book, and on the project website, we hope that the ultimate purpose of our efforts will not be forgotten. We hope that the art will encourage those it touches to go forward, improve their lives, and help make the world a better and more peaceful place.

DARLENE MARKOVICH
President, the Committee of 100 for Tibet
Executive Director, *The Missing Peace Project*

Biographies

LAURIE ANDERSON See artist biographies.

ARUN GANDHI, grandson of Mahatma Gandhi, has followed in his grandfather's footsteps by teaching the principles of nonviolence. In 1991, he and his wife Sunanda founded The M.K. Gandhi Institute for Nonviolence, based in Memphis, Tennessee. The institute's mission is "to promote and apply the principles of nonviolence locally, nationally, and globally to prevent violence and resolve personal and public conflicts through research, education, and programming."

JOHN GEIRLAND is a former editor at the online entertainment site Shockwave.com. He covered Internet entertainment for the *Industry Standard* and other new media magazines. His book *Digital Babylon* (Arcade) is an informal history of Hollywood and the Internet. Currently he writes about the intersection of science and culture and is a frequent contributor to *WIRED* magazine. He has a Ph.D. in social psychology.

JEFF GREENWALD has celebrated Passover with Paul Bowles, circled Tibet's Mt. Kailash with a demoness, and interviewed the Dalai Lama about *Star Trek*. He is the author of five travel books—including *Shopping for Buddhas, The Size of the World,* and *Scratching the Surface*—and is the founder of Ethical Traveler, a global alliance dedicated to human rights and environmental protection. Jeff launched his stage career in 2003, with a one-man show called "Strange Travel Suggestions."

DAVID & HI-JIN HODGE see artist biographies

JIM HODGES see artist biographies

PICO IYER works as a freelance journalist, and has contributed to publications such as *Time Magazine, Harper's Magazine, Conde Nast Traveler,* and *The New York Review of Books.* In a *Time* article on the leadup to the 1988 Olympic Games in Seoul, Iyer's exhaustive study of South Korea helped lift the veil on the quiet transformation of what many people remembered as an impoverished third-world country into the world's eleventh largest economy.

NOA JONES is a writer and editor living in New York City. She has written for the *Los Angeles Times, Shambhala Sun, NY Press,* and other publications. She wrote the commentary for the behind-the-scenes book about the Bhutanese film "Travellers and Magicians," directed by Dzongsar Khyentse Rinpoche. Noa serves as communications director for Khyentse Foundation, a not-for-profit organization that supports individuals and institutions engaged in the practice and study of Buddhism. She is writing a novel about disinformation and faith.

JOEL MAKOWER has been a writer and strategist on sustainable business, clean technology, and the green marketplace for nearly twenty years. He is founder of the sustainable business portal GreenBiz.com and co-founder of Clean Edge, a clean-tech research and publishing firm. A former nationally syndicated columnist, he is author of more than a dozen books, including *Beyond the Bottom Line: Putting Social Responsibility to Work for Your Business* and *The World* and *The E-Factor: The Bottom-Line Approach to Environmentally Responsible Business.* He is a Batten Fellow at the Darden School of Business at the University of Virginia and serves on the board or as an advisor for a number of for-profit and nonprofit organizations. *The Associated Press* has called him "The guru of green business practices."

DARLENE MARKOVICH has held senior positions during her twenty-eight year career at ALZA Corporation in marketing, human resources management, learning and development, communications and community relations. She has collaborated on numerous film projects, curated art exhibitions, and coordinated public events. In 1997, Darlene was awarded the Founder's Award, the highest achievement within ALZA. Markovich currently serves as President of the Committee of 100 for Tibet.

JOHN PERKINS is the author of *Confessions of an Economic Hit Man* (a *New York Times* bestseller), an explosive memoir about the underside of globalization and his own inner journey from willing servant of empire to impassioned advocate for the rights of oppressed people.

RANDY ROSENBERG, founded The Rosenberg Group, a curatorial and art consulting service, in 1982. She has curated many international art collections for organizations such as The World Bank, the International Finance Corporation, and Carnegie Endowment for International Peace. Rosenberg's work focuses on content-driven artwork and finding ways to promote the interaction between people and art in everyday life to engender a greater awareness of social, moral, spiritual and environmental issues in our world. As an exhibiting artist, Rosenberg has had numerous one-person shows at museums and galleries in the United States and abroad

KASUR TENZIN N. TETHONG is the founder of key Tibet initiatives in the U.S. including the Tibet Fund, Tibet House-New York, and the International Campaign for Tibet. He is a former Representative of H.H. the Dalai Lama in New York and Washington, D.C., and former Chairman of the Kashag, the Tibetan Cabinet. Tethong currently serves as Chairman of the Committee of 100 for Tibet and as a visiting scholar at Stanford University. He is also President of The Dalai Lama Foundation.

ROBERT A. F. THURMAN, PH.D. is a professor of Indo-Tibetan Studies in the Department of Religion at Columbia University, where he holds the Jey Tsong Khapa Chair and heads the American Institute of Buddhist Studies. He is president of Tibet House U.S., a non-profit organization dedicated to the preservation and promotion of Tibetan civilization. His recent books include *Inner Revolution: Life, Liberty and the Pursuit of Real Happiness* and *Mandala: The Architecture of Enlightenment*.

ARCHBISHOP DESMOND TUTU, recipient of the Nobel Peace Prize in 1984, retired as Archbishop of Cape Town, South Africa, in 1996. He then served as chairman of South Africa's Truth and Reconciliation Commission. His essay draws from his latest book, *God Has a Dream* (Doubleday, 2004).

LILLY WEI is an independent curator, essayist, and critic who frequently writes for *Art in America* and other publications, both nationally and internationally. She is also a contributing editor at *ARTnews* and *Art Asia Pacific*.

ARTISTS

MARINA ABRAMOVIC is a performance artist who investigates and pushes the boundaries of physical and mental potential. Abramovic's art is not sensationalism but a series of experiments aimed at identifying and defining the limits of control over her own body; of an audience's relationship with a performer; of art, and by extension, of the codes that govern society. Abramovic was born in 1946 in Belgrade, Yugoslavia, and currently lives in New York City.

SEYED ALAVI left his home in Iran as a student, immigrating to California to attend college. His work is often engaged with the poetics of language and space and their power to shape reality. Alavi has received grants from the NEA/ US–Japan Creative Artists' Fellowship, the Pollock-Krasner Foundation, the Creative Work Fund, and the LEF Foundation.

JANE ALEXANDER was born in Johannesburg in 1959 and studied at the University of Witwatersrand, Johannesburg, where she received her Bachelor of Fine Arts in 1982 and her MFA in 1988. Her international career began in 1994 with her participation in the Havana Biennale, followed by the Venice Biennale in 1995. Jane Alexander lives and works in Cape Town. Besides working as an artist, she also teaches sculpture, photography, and drawing at the University of Cape Town's Michaelis School of Fine Arts.

EL ANATSUI is one of West Africa's most renowned sculptors who has worked, lectured, and exhibited throughout Europe, West Africa, and the United States. He represented Nigeria at the Venice Biennial of 1990. Anatsui is of Ghanaian descent and is a sculptor and academic based in Nigeria.

LAURIE ANDERSON The art scene of the early 1970s fostered an experimental attitude among many young artists in downtown New York that attracted performance artist Laurie Anderson, born in 1947. She trained in violin as a child, and in college as a sculptor. Some of her earliest performances as a young artist took place on the street or in informal art spaces. Since that time, Anderson has gone on to create large-scale theatrical works which combine a variety of media—music, video, storytelling, projected imagery, sculpture—in which she is an electrifying performer.

KEN APTEKAR Growing up a second generation Jewish American in Detroit during the 1950s and '60s, painter Ken Aptekar's focus as an artist is the direct result of having lived through the conflicts arising within communities in transition: Midwestern Jews striving to assimilate, and African Americans asserting their identity in revolt against the restrictions imposed upon them.

RICHARD AVEDON American photographer Richard Avedon (1923-2004) has been referred to as our poet laureate of portraiture. His portrait work constitutes a modern-day pantheon of many of the major artistic, intellectual, and political figures of the late twentieth century, and as such, belongs to the time-honored tradition of public portraiture.

KIRSTEN BAHRS JANSSEN Sculpture and installation artist Kirsten Bahrs Janssen is a native Californian and is the daughter of a commercial artist father and Kabuki dancer mother. Ranging from intimate sculptural works to large-scale pieces, Bahrs Janssen's tactile work speaks about larger ideas in small digestible forms. The artist's work utilizes practical materials, labor, collabora-

tion, and skill as integral elements to the concept of a piece. She is based in San Francisco and works as a public school art teacher.

CHASE BAILEY was born in Kansas in 1947 and attended Kansas City Art Institute in the mid- to late-sixties. After a four-year tour with the Marine Corps in Vietnam, Bailey re-entered school and earned advanced degrees in Mathematics and Business. While completing his studies, he continued to paint and exhibit and participated in various solo and group exhibitions. After a long and successful career in technology, Bailey has resumed his full-time passion of painting and the arts. He currently resides in Paris.

TAYSEER BARAKAT was born in a refugee camp in Gaza in 1959, and currently resides in Ramallah on the West Bank. Like the Dalai Lama, Palestinian artist Barakat has been in exile from his homeland since 1960. Barakat earned his BA in Oil Painting from the College of Fine Art in Alexandria, Egypt. In 1998, he opened the Ziryab Café and art gallery, where he exhibits artwork of Palestinian artists.

SANFORD BIGGERS is a New York-based artist who was born in Los Angeles in 1970. His work draws upon a diverse range of sources including Eastern religions, black vernacular expression, 1970s process art, urban street culture, and new technologies. Biggers, who is also a musician, also borrows from the study of ethnological objects, popular culture, and the Dadaist tradition to deal with cultural and creative syncretism, art history, and politics. He received his MFA from the Art Institute of Chicago in 1999.

PHIL BORGES photographs have been collected and exhibited in museums and galleries worldwide for more than 25 years, and his award-winning books have been published in four languages. Phil teaches and lectures internationally and is cofounder of Blue Earth Alliance, a not-for-profit organization that sponsors photographic projects focusing on endangered cultures and threatened environments.

DOVE BRADSHAW, a multidisciplined artist whose career spans more than 30 years, was born in 1949. A New York City native, Bradshaw is best known for pioneering the use of indeterminacy in her sculpture, installation, performance, and film. From 1984–94, she served as Artistic Advisor of the Merce Cunningham Dance Company, for which she designed stage sets, lighting, and costumes.

GUY BUFFET currently lives in Maui, Hawaii, but was born in Paris in 1943. He is a painter whose works have been commissioned by many corporations, such as Inter-Continental Beachcomber and Westin Hotels, Champagne Perrier-Jouet, Williams Sonoma, and Grand Marnier.

DARIO CAMPANILE is a native of Rome, Italy, born in 1948. He is a painter whose intense realism and exploration of surrealism have won the praise of

peers and critics. Campanile is most renowned for his lyrical still-life oil paintings.He now lives in Hawaii and Northern California.

ANDY CAO came to the United States from his native Vietnam in 1979. After studying landscape architecture at California Polytech in Pomona, he started the Glass Garden in Los Angeles with the help of his business partner, Stephen Jerrom. Andy has received two full fellowships to Pilchuck Glass School in Seattle. In 2001 he was the only American designer to participate in the renowned garden festival at Chaumont-sur-Loire, France. In 2002 he received the prestigious Rome Prize Fellowship in Landscape Architecture.

SQUEAK CARNWATH received her MFA in 1977 from the California College of Arts and Crafts. She taught at the University of California–Davis for 15 years and in 1998 became Professor in Residence in the Department of Art Practice at the University of California–Berkeley, where she continues to teach while maintaining a studio in Oakland. Her often large-scale luminous paintings investigate the matter of being alive. She explores our daily routines, such as the act of waking up, going to our jobs, eating, and breathing, through observation and counting.

LONG-BIN CHEN was born in Taiwan, where he currently resides after having lived and studied in New York in the 1990s. The themes of the convergence of Chinese and American cultures and notions of consumerism are central to his work. Chen has received many prizes, awards, and international grants, and has exhibited internationally.

CHRISTO & JEANNE-CLAUDE are best known for producing enormous temporary "packaging projects" in which parks, buildings and entire outdoor landscapes are wrapped/surrounded in various types of cloth materals. Christo and Jeanne-Claude are a husband and wife team who have collaborated for more than 40 years on these projects, which can take more than ten years to realize due to the many levels of permissions they must obtain. They consider themselves as environmental artists because their works exist in both urban and rural environments.

COSTANTINO CIERVO Italian-born multimedia artist, has been living and working in West Berlin since 1984, where he has witnessed social and political history unfold in both dramatic and subtle ways. Bringing an academic background in electronics, economics, political science, and philosophy to his art, Ciervo (born in 1961) believes that great contemporary art exists in an international playing field.

CHUCK CLOSE The career of Close (born in1940) extends beyond his completed works of art. Highly renowned as a painter, Close is also a master printmaker who has, over the course of more than 30 years, pushed the boundaries of traditional printmaking. He achieved his international reputation by

demonstrating that a very traditional art form, portraiture, could be resurrected as a challenging form of contemporary expression. Today publications surveying contemporary art history routinely discuss his painting, and most modern art museums in the United States and Western Europe feature his work in their collections.

BERNARD COSEY was born in 1950 in Switzerland, and left school in the late 1960s to apprentice with Claude de Ribeaupierre, the only Swiss comic book author of his time. During his collaboration with Ribeaupierre, Cosey developed an interest in Eastern philosophy and a lifelong friendship with the artist. Cosey's characters are individuals on a quest to reconcile their pasts and their memories. They travel on extensive journeys in order to find peace.

SANTIAGO CUCULLU The Milwaukee-based Argentinean artist, born in 1969, was recently featured in the 2004 Whitney Biennale and in a solo show at the UCLA Hammer Museum. Cucullu creates large-scale drawings and installations that juxtapose images of progressive, historical figures and events drawn from his own biographical details, creating composite visual storyboards that mix references to high and low culture that range across the Northern and Southern Hemispheres, and freely jumble the contemporary with the historical.

BINH DANH, born in Vietnam in 1977, uses 19th-century photographic techniques to burn images into plants. The artist develops his images in the leaves, using chlorophyll as a medium. He was in residency at Cite Internationale Des Arts in Paris from late-September 2004 to March 2005. Danh received his BFA in Photography from San Jose State University and MFA from Stanford University in 2004. He lives and works in the San Francisco Bay Area.

LEWIS DESOTO Born in 1954, Lewis deSoto is known for creating public projects and sculptural installations that incorporate sound, video, and theatrical lighting. His work engages cosmological questions and notions of self, and plays with inherent phenomena. Lewis was educated at University of California-Riverside and the Claremont Graduate University, lives in California, and is currently a Professor of Art at San Francisco State University.

FILIPPO DI SAMBUY Through painting, Italian artist Filippo di Sambuy creates symbols that arise from visions of his perception. He believes that the "Sacred Idea" that is at the origin of a work of art does not conform to time. Di Sambuy considers painting as a tradition immutable, and as such, a unique activity to trespass the limits of time and space imposed by the choices of contemporary awareness. He sees the artist as a channel that tries to reveal the invisible by means of the visible and embodies the divinity in a form or through a symbol through which he speaks and communicates with the observer.

DORIS DOERRIE & MICHAEL WENGER After studying acting, philosophy and psychology in the USA, German artist Doris Doerrie studied at the Acad-

emy of Television & Film (HFF/M) in Munich, where she is also an instructor today. In addition to being an accomplished filmmaker with such award-winning films as *Men* (*Maenner*, 1985) and *Naked* (*Nackt*, 2002) under her belt, she is also an artist and a writer of novels, short stories and children's books. For five days in the summer of 2005, Doerrie and San Francisco Zen Center's Michael Wenger collaborated on a film, which took place in one of the Center's remote retreats, Tassajara, near Big Sur, California. Wenger, who has edited several books on Buddhism, has practiced at the San Francisco Zen Center since 1972 and serves as Dean of Buddhist Studies.

PEIG FAIRBROOK & ADELE FOX Most of the faces Peig Fairbrook encountered as a child in Ireland were Caucasian, but her family had a strong connection with Africa. Her brother Raymond was a missionary in Biafra. During the devastating wars in that country, several African students came to live in her home and became part of the extended family. Adele Fox is a California-based artist whose work has been exhibited throughout the state. She received a BA from California State University in 1985, and studied painting at the San Francisco Art Institute.

ERA & DONALD FARNSWORTH For the past twenty years the Farnsworths have been involved in Magnolia Editions, a fine art print studio and facility for handmade paper based in Oakland, California, that encourages experimentation and collaboration while exploring new technologies for their creations.

SPENCER FINCH Through sculpture, performance, video, painting, drawing and other media, Spencer Finch (b. New Haven, Connecticut) deals with issues of color, language, vision, memory, perception, and representation through such nature-derived concepts as wind movements, properties of light, the distance to the stars, and moments in time. Finch received his MFA from the Rhode Island School of Design in 1989 and currently lives and works in New York.

SYLVIE FLEURY The year 1990 marked the start of Sylvie Fleury's career, which has rapidly soared to great heights on the international art scene. The fascination her work commands is due in large measure to the deliberate blurring of the line between art and fashion. Her technique starts out with the appropriation of consumer icons or fetishes, and ends up with their transfer to a different scale of values.

LOUIS FOX & FREE RANGE GRAPHICS Louis Fox, raised in Woodstock, NY, is one of the founders and principal of the graphic design and animation company Free Range who describes his company as "creativity with conscience." Based in Berkeley, California and Washington, D.C., Fox was previously an art director in the film industry.

ADAM FUSS is a British artist born in 1961 who lives and works in New York. Having worked as a commercial photographer, he is conscious of what he calls "the pervasive technological-consumerist culture." In response to this he has returned to the simplest photographic means and creates work that evokes an era of photography not commonly seen today.

JUAN GALDEANO Conceptual artist Juan Galdeano, born in 1955 in Spain, often creates objectless installations—his materials could be temperature, smoke, or soap bubbles. In his series of bubble machines titled *The Perfect Moment*, the artist dreams of a world where there is no AIDS or cancer, a world with no disease or pain.

RUPERT GARCIA One of the leading artists of the Chicano Movement of the late 1960s and early '70s, Rupert Garcia participated in the formation of several seminal West Coast civil rights movement oriented workshops and collectives. Garcia's work has been exhibited in such major institutions as the San Francisco Museum of Modern Art and the San Francisco Mexican Museum. The bulk of Garcia's work is housed in the National Archives of American Art at the Smithsonian Institution in Washington, D.C.

ROBIN GARTHWAIT & DAN GRIFFIN Owners of Garthwait & Griffin Films based in Menlo Park, CA, the couple have produced a number of films on Tibet, including: *Tibet's Stolen Child*, *The World Isn't Listening*, *Missing in Tibet*, and *The Dalai Lama Visits Washington, D.C.* Garthwait and Griffin, whose work focuses primarily on human rights, the environment and science, were nominated for an Emmy Award for their public service announcement, *Why Are We Silent?*

RICHARD GERE, best known as an actor, is also an accomplished pianist, photographer, social activist, composer and humanitarian. Gere's public charity, Healing the Divide, works across a wide range of issues ranging from the growing HIV/AIDS crisis in Asia to prison reform to peace in the Middle East. A student and friend of the Dalai Lama, he has made numerous journeys throughout India, Nepal, Zanskar, and Tibet. As a committed photographer, he has worked extensively in these regions, showing his photographs in galleries around the world.

LOSANG GYATSO was born in Lhasa, Tibet, and grew up in India and Britain. He arrived in the United States in 1974 and studied art in San Francisco. Gyatso worked as an art director in New York for 15 years, producing work in both film and print that have won many industry awards. Throughout this period he continued to explore his work as a contemporary Tibetan artist. Gyatso currently lives in Colorado, devoting his time to painting and working to create awareness for contemporary Tibetan art.

HELEN MAYER HARRISON & NEWTON HARRISON Considered leading pioneers of the eco-art movement, the collaborative husband and wife team of Helen Mayer Harrison and Newton Harrison (aka The Harrisons, or The Harrison Studio) has worked for more than thirty years with biologists, ecologists, and urban planners to initiate collaborative dialogues and uncover ideas and solutions to support biodiversity and community development.

DAVID & HI-JIN HODGE bring an internationally recognized background in design to the discipline of filmmaking, and together in 2001, founded Hodge-Pictures. Their projects include product, commercial, and promotional films, as well as documentaries and artistic installations on a diverse range of topics. Their clients include Apple, Sony, Herman Miller and DoCoMo.

JIM HODGES, born in 1957, is a New York-based sculptor who uses ordinary materials in his art in order to convey the most transient and poignant moments in life. Raised in Spokane, Washington, Hodges received his MFA in 1986 from the Pratt Institute in Brooklyn, New York.

JENNY HOLZER, born in 1950, is a conceptual artist most known for her work that exists in public spaces. Holzer's art came to prominence in the late 1970s and early '80s when she began to plaster posters from her *Truism* series throughout the streets of New York City. Holzer has since produced a variety of texts with points of view ranging from inflammatory manifesto to bleak resignation. Her transformation of the Solomon R. Guggenheim Museum in New York into a moving spiral of electronic information and her widely praised pavilion at the Venice Biennale, composed of LEDs, benches, and inscribed marble floors, have fused the text with the architecture and sculpture.

TRI HUU LUU Born in Saigon in 1972, photographer Tri Huu Luu escaped from Vietnam at age sixteen to avoid being drafted into the war between Cambodia and his native country. Since then, Luu has spent the past few years traveling throughout Asia to photographically explore the Buddhist idea of detachment in relationship to individual identity and the perception of other.

ICHI IKEDA Osaka-born artist Ichi Ikeda creates artwork, widely known as WaterArt projects, that concerns the earth's supply of water. Born in 1943, Ikeda considers water to be Earth's most precious resource which will help deliver our planet safely into the future. As a result, he has dedicated the majority of his prolific career to raising global awareness around water issues and conservation through international conferences, community activism, public performance, and his interactive WaterArt installations as a catalyst for change.

YOKO INOUE graduated with an MFA from Hunter College, New York in 2000. Inoue, born in 1964, creates installations that investigate the interface of spirituality and commerce, and believes that advertising fosters patterns of consumption and desire. Her work also seeks to address Japanese and American

traditions that result in a dialogue about the complexity of cultural meaning. She resides in Brooklyn, New York.

ILYA & EMILIA KABAKOV is the one of most influential artists to emerge from the former Soviet Union. His work has been exhibited at international major museums including the Museum of Modern Art in New York, and at the Centre Pompidou in Paris, the 1995 Venice Biennale, and the 1997 Münster Sculpture Project. The Palace of Projects was Kabakov's first collaboration with his wife Emilia. Ilya and Emilia Kabakov now live in New York.

JESAL KAPADIA, previously a graphic designer, is currently a video artist whose work revolves around the very experience of migration and its effects on the immigrant body. The hybridization, appropriation, and assimilation that occurs as a consequence, is what she represents and questions in her work. Kapadia is also co-editor of the arts for the journal *Rethinking Marxism* and is a graduate of the Whitney Museum's Independent Study Program in New York City.

ANISH KAPOOR Born in Mumbai, India, Anish Kapoor has lived and worked in London since the early 1970s. His work has been exhibited worldwide and is held in numerous private and public collections, including the Tate Gallery in London, the Museum of Modern Art in New York, the Reina Sofia in Madrid, and the Stedlijk Museum in Amsterdam.

KIMSOOJA was born in 1957 in Taegu, Korea. She attended Ecole Nationale Supérieure des Beaux-Arts in Paris on a French Government scholarship immediately following Graduate School at Hong-Ik University in Seoul, Korea. Her work spans many different media including performance, photography, video and installation. Kimsooja now lives and works in New York.

ENRIQUE MARTINEZ CELAYA was born in Palos, Cuba in 1964. He started painting at age 11, but eventually pursued graduate studies in quantum electronics. After deciding to abandon a promising career in the sciences, Martínez Celaya redirected his career to focus on painting. In 1994, he received his M.F.A. at the University of California, Santa Barbara and became a tenured professor at Pomona College and the Claremont Graduate University from 1994–2003. Martínez Celaya is a prolific painter, sculptor, photographer, poet and writer who mines the transient world of time and memory, identity and displacement. His images range from a body emerging from a murky tar-painted landscape to lightening paintings created of ash, blood and mirror. The artist currently resides in Los Angeles.

NEFELI MASSIA is a Greek artist whose work, both abstract and theoretical, probes the recesses of the psychological space of our physiology, the brain, to explore our sense of self. Notions of identity, consciousness, humanity, existence and meaning are the keys to her ongoing search for knowledge. Massia

has participated in many international exhibitions in Bulgaria, the Netherlands, Serbia, Venezuela, and the former Yugoslavia. Her work is also housed in museums and private collections around the world.

YUMYO MIYASAKA Japanese-born artist Miyasaka studied in India with the master Tibetan artist Kalsang Lodroe Oshoe. Miyasaka assisted Kalsang in creating the frescos at the Kalacharka Assembly Hall at the Dalai Lama's residence in Dharamsala. Miyasaka is currently working in Japan on a series of thangkas of the life of the Buddha, following strict laws of Tibetan iconography.

GABRIELA MORAWETZ is a Polish native who has been living and working in Paris for more than 20 years. Her art contains a strong magical aspect, and the human form serves as the most important figure in her mystical universe. However, the figure is removed from any particular time and place and belongs to a world of nature—one saturated with story-telling, spirituality, and mystery.

KISHO MUKAIYAMA creates minimal paintings that express quietude and introspection, and can be described as both painting and sculpture. The artist states that he feels a sense of awe before nature and is a believer in the Shingon sect of Kukai Buddhism. He describes the quality of his life as living day to day, trying to create and maintain a humble faith in peace. Mukaiyama was born in 1968 in Osaka, Japan.

TOM NAKASHIMA While growing up during World War II, Nakashima's extended family members and countrymen were held in internment camps. This confinement is a major theme of his allegorical work. Nakashima's work is in the collections of numerous museums across the United States and in Japan, including the National Museum of American Art, the Corcoran Museum, and the Long Beach Museum of Art.

YOSHIRO NEGISHI was born in Nagano in 1951. His abstract paintings are marked by a dynamic blend of tones and colors brought about by the subtle balance between black and other hues, which he describes as "colored space". For Negishi, infinity stretches on in a vague space of color. In 1973 he graduated from the Painting Department at Musashino Art University. Three years later, he attended the School of the Museum of Fine Arts in Boston and in 1977, completed the school's post-graduate program.

DANG NGO is a Los Angeles-based photographer who is a chronicler of human rights and passive resistance demonstrations. He has worked with the Ruckus Society to document their training to help environmental, human rights, and social justice organizers with the tools, training, and support needed to achieve their goals through direct action. As a photojournalist, Ngo has documented human rights conditions in Burma, casualties of landmines, demonstrations in the United States, the environmental impact of the logging industry, and the survival of the rain forest in Southeast Asia.

MICHELE OKA DONER has been an artistis for four decades. She is best known for her monumental public art, but also creates sculpture, furniture, jewelry and functional objects. Oka Doner's work is fueled by a lifelong study and appreciation of the natural world. Born in Miami Beach, Florida, Oka Doner was educated in Ann Arbor, Mich., and is currently based in New York City.

ROBERT & SHANA PARKEHARRISON are photographers and a husband and wife collaborative team who use props, staging, and poetic license to distill and redress complex environmental problems and failed technological systems with dark humor. The creation of their images incorporates performance, sculpture, collage, and painting. Shana's background as a dancer and metalsmith are evident in the results. The couple reside in Massachusetts.

SUSAN PLUM Born in 1944, Susan Plum is an iconic figure in the world of glass who has been influenced by her Mesoamerican upbringing in Mexico City. Mayan mythology, poetic and religious imagery, and traditions of light and energy as healing forces are constant themes in her work. Psychiatrist Carl Jung's definition of glass as solidified water or air, representing the spirit, was partially responsible for influencing Plum to chose flameworking as her medium of visual expression. Plum is also involved in numerous humanitarian efforts, and currently lives and works in San Miguel de Allende, Mexico.

ROSEMARY RAWCLIFFE British-born Rosemary Rawcliffe is an award-winning producer and director with more than 25 years of international experience in television, film, video, and theatrical production. In 1976 Rawcliffe co-founded her own production company, Frame of Mind Films, and has produced countless award-winning programs. Rawcliffe is also a founding member of The Dalai Lama Foundation, based in Palo Alto, California.

TENZING RIGDOL Born in Kathmandu, Nepal, in 1982, Rigdol is a 2004 graduate of the University of Colorado at Denver with a degree in painting, drawing, art history and philosophy. He was the recipient of a scholarship to study Tibetan classical painting in Dharamsala, India. At a young age he was admitted to the School of Tibetan Thangkha Painting, where he studied under the guidance of Master Phenpo Tentar and Tenzing Gawa. He also studied traditional Tibetan carpet design in an affiliated institute of Tibetan Children's Village, a school founded by H. H. the Dalai Lama.

MICHAL ROVNER is an Israeli photographer and video artist who has lived in New York since 1987. Rovner's work is the product of painstaking digital editing that whittles away recognizable individual traits from whatever living object she is filming. Her work has been labeled as "socio-poetic art"—an artfulness infused with a political sensibility stemming from her lifelong experiences with conflict in her native Middle East. She trained in classical ballet and studied philosophy and cinema before beginning her art career as a photographer.

RYUICHI SAKAMOTO has made a career for himself by playing everything from techno to light classical to bossa nova to opera. In 1987 the original score he co-composed for Bernardo Bertolucci's *The Last Emperor* won an Oscar® and a Grammy®. A little more than 10 years later, his solo piano composition "Energy Flow" was a million-selling No. 1 hit in Japan. In the summer of 2005, Sakamoto released the CD *Chasm*.

SEBASTIAO SALGADO Brazilian photographer Salgado is one of the most respected photojournalists working today. Appointed a UNICEF Special Representative in 2001, he has dedicated himself to chronicling the lives of the world's dispossessed. Educated as an economist, Salgado began his photography career in 1973. He has photographed the lives of the poor in Latin America and the drought in Northern Africa, and has undertaken a monumental project of documenting manual labor worldwide. His most well-known body of work records the global phenomenon of the mass-displacement of peoples.

SALUSTIANO The subject, to Spanish-born artist Salustiano, is invariably the portrait. Born in 1965, Salustiano chooses his subjects striving for an aesthetic result, but also the emotion and expression of the glance that creates a connection with the viewer. His work has been widely exhibited in galleries and museums such as the Malone Gallery, Madrid; Gallery Liquid Space, Gijón; Cavecanem Gallery, Seville; as well as the Venice Biennale.

ANDRA SAMELSON has had works exhibited in such places as the International Print Center and the Wooster Arts Space in New York City, the Florence Lynch Gallery at the Palm Springs Desert Museum in California, and L' Art Contemporaire in Paris. In 2004 she completed *Heaven on Earth*, a public artwork at the Second Street Station in Hoboken, New Jersey, commissioned by New Jersey Transit.

ARLENE SHECHET creates works inspired by Buddhist iconography, growth, and enlightenment in a variety of forms and materials. Known for her installations that reinterpret monuments, temples, and cities using innovative processes, she always relates the images back to her Eastern influences. Shechet's installations are meditative spaces filled with a myriad of constructed vessels and, as with Buddhism, her art is very much about the journey. Shechet lives and works in New York City.

JAUNE QUICK-TO-SEE SMITH, a member of the Flathead Salish tribe, is one of the most acclaimed Native American Indian artists today. Smith has had over 80 solo exhibits in the past 30 years. Over that same time, she has organized and curated over 30 exhibitions and lectured at more than 175 universities, museums, and conferences internationally. Smith has completed several collaborative public art works, such as the floor design in the Great Hall of the new Denver Airport, an in-situ sculpture piece in Yerba Buena Park, San Francisco, and a mile-long sidewalk history trail in West Seattle.

MIKE & DOUG STARN, sometimes known as the Starn Twins, are identical twin brothers who have been collaborators in photography since they were thirteen. Born in 1961 and raised in New Jersey, the brothers are known for their large-scale photographic constructions that not only reflect their collaborative style, but their quest to radically revise the role of photography as an art medium. They graduated from the School of the Museum of Fine Arts in Boston in 1985.

PAT STEIR is a painter and printmaker who has exhibited her work worldwide since the 1970s. Steir has taught extensively in New York and California, and was a founding member of Printed Matter book store, also an organization that has helped define the meaning of artist books. She lives in New York and Amsterdam.

HOANG VAN BUI is an installation artist and a professor of art at the University of Tampa, who immigrated to Florida when he was eight years old. Van Bui has created an impressive body of work with mixed media, small bronze studies, and wall mounted constructions. He has worked with orphans and special-needs children living in desperate conditions.

ADRIANA VAREJÃO Born in 1964 in Rio de Janiero, Brazil, where she currently lives and works, Adriana Varejão investigates the hybridism of Brazilian culture and draws upon a variety of sources that are figurative, decorative, theatrical, allegorical, biological, and popular. Varejão's work has appeared at the Guggenheim, the Museum of Modern Art in New York, the Walker Art Center, and the Cartier Foundation for Contemporary Art in Paris

BILL VIOLA is widely recognized as a leading video artist. For over 30 years he has created videotapes, architectural video installations, sound environments, electronic music performances, and works for television broadcast. His single channel videotapes have been broadcast and presented cinematically around the world, while his writings have been published and anthologized for international readers. Viola is an American artist born in 1951.

INKIE WHANG Born in Choohgju, Korea in 1951, Inkie Whang received his MFA in painting from Pratt Institute in 1981 and his BFA from Seoul National University in 1975. He was selected as the Korean National Museum of Contemporary Art's "Artist of the Year" in 1997 and was one of three Korean artists selected to represent the country at the 2003 Venice Biennial. In the same year, the artist's work was also exhibited at Art Basel in Switzerland. His art was added to the permanent collection of the Metropolitan Museum of Art in New York in 2003.

WILLIAM WILEY is one of the most important contemporary artists to emerge from the San Francisco Bay Area during the 1970s. He was one of a group of artists who became dissatisfied with the limitations of pure abstraction and began to develop an idiosyncratic and introspective imagery in his art that he has explored over a 40-year career. His work weaves a connective tissue between the philosophy of Zen Buddhism and developments in the public arenas of politics, the environment, and global conflicts. Wiley was born in 1937 and lives in Marin County, north of San Francisco, California.

KATARINA WONG A second-generation American of Chinese-Cuban heritage, Katarina Wong is an artist and curator who lives and works in New York City. Wong draws upon her family's migratory history and melds it with the Buddhist concept of interdependent origination. She holds both an MFA in sculpture from the University of Maryland at College Park, and a Master of Theological Studies in Buddhist Studies from the Harvard Divinity School.

YURIKO YAMAGUCHI A native of Osaka, Japan, Yuriko began her career as a sculptor in 1971 after moving to the United States. She melds the aesthetic traditions of her homeland with a labor-intensive poetic synthesis and direct carving. She is a recipient of grants from the National Endowment for the Arts and the Virginia Commission of the Arts. Her work is collected by museums around the world. Yuriko has completed numerous public art commissions.

Acknowledgments

WE ARE MOST GRATEFUL to His Holiness the Fourteenth Dalai Lama, who inspired this project, and to the Office of His Holiness the Dalai Lama for their most kind assistance. Our deep thanks to the 88 artists who, through the gift of their artworks, formed the foundation of The Missing Peace project. To the wonderful people at the Fowler Museum of Cultural History, Los Angeles, the Loyola University Museum of Art, Chicago, and the Rubin Museum of Art and the School of Visual Arts, New York City, goes our gratitude for being the first hosts of "The Missing Peace: Artists Consider the Dalai Lama." We thank our publisher, Raoul Goff, for his investment and dedication to seeing this book manifest and to Lisa Fitzpatrick for her editorial direction and guidance.

SPONSORS: The Committee of 100 for Tibet, The Dalai Lama Foundation, Ron Haak and Darlene Markovich, Sandra and Bernard Magnussen, Betlach Family Foundation, the Zaffaroni Foundation, Anonymous, Chase Bailey, Carolyn Zecca-Ferris, Yvon Chouinard, Fred Segal, Ryan Magnussen, David and Randy Taran, Susan Fairbrook, Bert Centofante, Suzanne Martin, John Reuter, Douglas and Marie Barry, Peter and Harise Staple, and Sam and Kim Webster. In-kind sponsorship: Tank Design, Beals Martin, SPUR Projects, Me&Ro, Alain Despert, Jean Simpson, Joy Kutaka Kennedy in memory of Sadako Kutaka, Magnolia Editions, Marna Clark, Artists to Watch, FACE Inc, Graphics Arts West, Gale Bailey, Promemoira/Moleskine, Chameleon Creations, Penguin Books, David Kimball Anderson, and Bond No. 9.

ADVISORY BOARD: Rebekah Alperin, David Adamson, Chase Bailey, Guy Buffet, Harold Fethe, Robin Garthwait, David Gleeson, Vladimir Groh, Tony Hoeber, Laura Jason, Gordon Knox, Cathy Kimball, Begona Malone, Seiichi Mizuno, Fumio Nanjo, Marcia Tanner, Tenzin N. Tethong, Rafael Vostell, Lilly Wei, Nina Zagaris.

THE MISSING PEACE TEAM AND FRIENDS: Charles Albert, Garry Bailey, Lou Bailey-Boyle, Anna Beuselinck, Jane Brady, Michelle Breiner, Allison Brustin, Lydia Carriere, Tashi Chodron, Isa Cocallas, Chris Chope, Marsha Clark, Susan Fairbrook, Wilson Farrar, Ron Haak, Diane Hatz, Carolyn Hayes, David and Hi-Jin Hodge, Rebecca Jennison, Athena Kakoliris, Derek Kidd, P. Christiaan Klieger, Vassi Koutsaftis, Stefanie Krasner, Lisa Kristine, Joy Kutaka-Kennedy, Darlene Markovich, Kit Moulton, Mark Moulton, Sarah Moulton, Anne Novak, Bridget O'Malley Baldwin, Darcy Padilla, Sharon Parkinson, Cherilyn Parsons, Planners Collaborative, Mary Rauner, Marianne Richter, Ellen Rose, Randy Rosenberg, Richard Schram, Jim Schuyler, Uwe Schwarzer Shambhavi Sarasvati, Wendy Smith, Gail Stanley, Krysia Swift, Randy Taran, Kelsang Tahuwa, Zayden Tethong, Elizabeth Tench, Morgan Tench, Tracie Thompson, Debra Torres, Giovsanni Vassallo, Barry Willis, Jean Yao, Jigme Yugay, Sharri Yugay.

SPECIAL THANKS TO: Chhime R. Chhoekyapa, Tendzin Choegyal, Anne Firth-Murray, Father Michael Garanzini, Kay Sprinkel Grace, Bunthoeun Hack, Lama Kunga, Claude Levenson; Frank and Rita Lonergan, Sandra Magnussen, Jonathan McCabe, Arjia Rinpoche, Fred and Julia Shepardson, Sharon Stone, Tenzin Takla, Tenzin Geyche Tethong, Michelle Townsend, Charlie Trotter, Venerable Geshe Gyeltsen, and to the Board members of the Committee of 100 for Tibet and The Dalai Lama Foundation.

MIKE & DOUG STARN, sometimes known as the Starn Twins, are identical twin brothers who have been collaborators in photography since they were thirteen. Born in 1961 and raised in New Jersey, the brothers are known for their large-scale photographic constructions that not only reflect their collaborative style, but their quest to radically revise the role of photography as an art medium. They graduated from the School of the Museum of Fine Arts in Boston in 1985.

PAT STEIR is a painter and printmaker who has exhibited her work worldwide since the 1970s. Steir has taught extensively in New York and California, and was a founding member of Printed Matter book store, also an organization that has helped define the meaning of artist books. She lives in New York and Amsterdam.

HOANG VAN BUI is an installation artist and a professor of art at the University of Tampa, who immigrated to Florida when he was eight years old. Van Bui has created an impressive body of work with mixed media, small bronze studies, and wall mounted constructions. He has worked with orphans and special-needs children living in desperate conditions.

ADRIANA VAREJÃO Born in 1964 in Rio de Janiero, Brazil, where she currently lives and works, Adriana Varejão investigates the hybridism of Brazilian culture and draws upon a variety of sources that are figurative, decorative, theatrical, allegorical, biological, and popular. Varejão's work has appeared at the Guggenheim, the Museum of Modern Art in New York, the Walker Art Center, and the Cartier Foundation for Contemporary Art in Paris

BILL VIOLA is widely recognized as a leading video artist. For over 30 years he has created videotapes, architectural video installations, sound environments, electronic music performances, and works for television broadcast. His single channel videotapes have been broadcast and presented cinematically around the world, while his writings have been published and anthologized for international readers. Viola is an American artist born in 1951.

INKIE WHANG Born in Choohgju, Korea in 1951, Inkie Whang received his MFA in painting from Pratt Institute in 1981 and his BFA from Seoul National University in 1975. He was selected as the Korean National Museum of Contemporary Art's "Artist of the Year" in 1997 and was one of three Korean artists selected to represent the country at the 2003 Venice Biennial. In the same year, the artist's work was also exhibited at Art Basel in Switzerland. His art was added to the permanent collection of the Metropolitan Museum of Art in New York in 2003.

WILLIAM WILEY is one of the most important contemporary artists to emerge from the San Francisco Bay Area during the 1970s. He was one of a group of artists who became dissatisfied with the limitations of pure abstraction and began to develop an idiosyncratic and introspective imagery in his art that he has explored over a 40-year career. His work weaves a connective tissue between the philosophy of Zen Buddhism and developments in the public arenas of politics, the environment, and global conflicts. Wiley was born in 1937 and lives in Marin County, north of San Francisco, California.

KATARINA WONG A second-generation American of Chinese-Cuban heritage, Katarina Wong is an artist and curator who lives and works in New York City. Wong draws upon her family's migratory history and melds it with the Buddhist concept of interdependent origination. She holds both an MFA in sculpture from the University of Maryland at College Park, and a Master of Theological Studies in Buddhist Studies from the Harvard Divinity School.

YURIKO YAMAGUCHI A native of Osaka, Japan, Yuriko began her career as a sculptor in 1971 after moving to the United States. She melds the aesthetic traditions of her homeland with a labor-intensive poetic synthesis and direct carving. She is a recipient of grants from the National Endowment for the Arts and the Virginia Commission of the Arts. Her work is collected by museums around the world. Yuriko has completed numerous public art commissions.

Acknowledgments

WE ARE MOST GRATEFUL to His Holiness the Fourteenth Dalai Lama, who inspired this project, and to the Office of His Holiness the Dalai Lama for their most kind assistance. Our deep thanks to the 88 artists who, through the gift of their artworks, formed the foundation of The Missing Peace project. To the wonderful people at the Fowler Museum of Cultural History, Los Angeles, the Loyola University Museum of Art, Chicago, and the Rubin Museum of Art and the School of Visual Arts, New York City, goes our gratitude for being the first hosts of "The Missing Peace: Artists Consider the Dalai Lama." We thank our publisher, Raoul Goff, for his investment and dedication to seeing this book manifest and to Lisa Fitzpatrick for her editorial direction and guidance.

SPONSORS: The Committee of 100 for Tibet, The Dalai Lama Foundation, Ron Haak and Darlene Markovich, Sandra and Bernard Magnussen, Betlach Family Foundation, the Zaffaroni Foundation, Anonymous, Chase Bailey, Carolyn Zecca-Ferris, Yvon Chouinard, Fred Segal, Ryan Magnussen, David and Randy Taran, Susan Fairbrook, Bert Centofante, Suzanne Martin, John Reuter, Douglas and Marie Barry, Peter and Harise Staple, and Sam and Kim Webster. In-kind sponsorship: Tank Design, Beals Martin, SPUR Projects, Me&Ro, Alain Despert, Jean Simpson, Joy Kutaka Kennedy in memory of Sadako Kutaka, Magnolia Editions, Marna Clark, Artists to Watch, FACE Inc, Graphics Arts West, Gale Bailey, Promemoira/Moleskine, Chameleon Creations, Penguin Books, David Kimball Anderson, and Bond No. 9.

ADVISORY BOARD: Rebekah Alperin, David Adamson, Chase Bailey, Guy Buffet, Harold Fethe, Robin Garthwait, David Gleeson, Vladimir Groh, Tony Hoeber, Laura Jason, Gordon Knox, Cathy Kimball, Begona Malone, Seiichi Mizuno, Fumio Nanjo, Marcia Tanner, Tenzin N. Tethong, Rafael Vostell, Lilly Wei, Nina Zagaris.

THE MISSING PEACE TEAM AND FRIENDS: Charles Albert, Garry Bailey, Lou Bailey-Boyle, Anna Beuselinck, Jane Brady, Michelle Breiner, Allison Brustin, Lydia Carriere, Tashi Chodron, Isa Cocallas, Chris Chope, Marsha Clark, Susan Fairbrook, Wilson Farrar, Ron Haak, Diane Hatz, Carolyn Hayes, David and Hi-Jin Hodge, Rebecca Jennison, Athena Kakoliris, Derek Kidd, P. Christiaan Klieger, Vassi Koutsaftis, Stefanie Krasner, Lisa Kristine, Joy Kutaka-Kennedy, Darlene Markovich, Kit Moulton, Mark Moulton, Sarah Moulton, Anne Novak, Bridget O'Malley Baldwin, Darcy Padilla, Sharon Parkinson, Cherilyn Parsons, Planners Collaborative, Mary Rauner, Marianne Richter, Ellen Rose, Randy Rosenberg, Richard Schram, Jim Schuyler, Uwe Schwarzer Shambhavi Sarasvati, Wendy Smith, Gail Stanley, Krysia Swift, Randy Taran, Kelsang Tahuwa, Zayden Tethong, Elizabeth Tench, Morgan Tench, Tracie Thompson, Debra Torres, Giovsanni Vassallo, Barry Willis, Jean Yao, Jigme Yugay, Sharri Yugay.

SPECIAL THANKS TO: Chhime R. Chhoekyapa, Tendzin Choegyal, Anne Firth-Murray, Father Michael Garanzini, Kay Sprinkel Grace, Bunthoeun Hack, Lama Kunga, Claude Levenson; Frank and Rita Lonergan, Sandra Magnussen, Jonathan McCabe, Arjia Rinpoche, Fred and Julia Shepardson, Sharon Stone, Tenzin Takla, Tenzin Geyche Tethong, Michelle Townsend, Charlie Trotter, Venerable Geshe Gyeltsen, and to the Board members of the Committee of 100 for Tibet and The Dalai Lama Foundation.

ESSAYISTS

"The End of the Moon." Copyright © by Laurie Anderson. Published with permission from Laurie Anderson.

"Nonviolence: The Only Hope." Copyright © by Arun Gandhi. Published with permission from Arun Gandhi.

"Buddha on the Brain." Copyright © by John Geirland. Published with permission from John Geirland.

"Do Aliens have a Buddha Nature?" Copyright © by Jeff Greenwald. Published with permission from Jeff Greenwald.

"Exerpts from Video Interviews." Copyright © by David and Hi-Jin Hodge. Published with permission from David and Hi-Jin Hodge.

"Messenger from a Burning House." Copyright © by Pico Iyer. Published with permission from Pico Iyer.

"The Dalai Lama and the Rivers of Tibet." Copyright © by Joel Makower. Published with permission from Joel Makower.

"The Dalai Lama, Indigenous Shamas, Art and Unity of All Things." Copyright © by John Perkins. Published with permission from John Perkins.

"Walking with the Dalai Lama." Copyright © by Kasur Tenzin N. Tethong. Published with permission from Kasur Tenzin N. Tethong.

"Tibetan Buddhism." Copyright © by Robert A. Thurman. Published with permission from Robert A. Thurman.

"Truth and Reconciliation." From God Has a Dream: A Vision of Hope For Our Time by Desmond Tutu and Douglas Abrams, copyright © 2004 by Archbishop Desmond Tutu. Used by Permission of Doubleday, a division of Random House, Inc.

"Only Connect." Copyright © by Lilly Wei. Published with permission from Lilly Wei.

ARTISTS

At the Waterfall, 2000—2003. Copyright © by Marina Abramovic. Printed with permission from Marina Abramovic.

Sign of the Times, 2006. Copyright © by Seyed Alavi. Printed with permission from Seyed Alavi.

Harbinger with Rainbow, 2004. Copyright © by Jane Alexander. Printed with permission from Jane Alexander.

Untitled, 2005. Copyright © by El Anatsui. Printed with permission from El Anatsui.

From The Air, 2006. Copyright © by Laurie Anderson. Printed with permission from Laurie Anderson.

I Saw the Figure Five in Gold, 2005. Copyright © by Ken Aptekar. Printed with permission from Ken Aptekar.

His Holiness the Dalai Lama and Monks (detail), 1998. Copyright © by Richard Avedon. Printed with permission from Richard Avedon.

The Golden Thread, 2006. Copyright © by Kirsten Bahrs Janssen. Printed with permission from Kirsten Bahrs Janssen.

Evolution into a Manifestation (Evolution vers une Incarnation), 2005. Copyright © by Chase Bailey. Printed with permission from Chase Bailey.

Untitled, 2005. Copyright © by Tyseer Barakat. Printed with permission from Tyseer Barakat.

Hip-Hop Ni Sasagu (In Fond Memory of Hip-Hop), 2003—2004. Copyright © by Sanford Biggers. Printed with permission from Sanford Biggers.

Shelo & Benba, Nyalam, Tibet, 1994. Copyright © by Phil Borges. Printed with permission from Phil Borges.

Salt, Half-Heard, 1996—2006. Copyright © by Dove Bradshaw. Printed with permission from Dove Bradshaw.

His Holiness and the Bee (How a Little Annoyance Can Bring Great Joy), 2005. Copyright © by Guy Buffet. Printed with permission from Guy Buffet.

La Pace E Con Noi (Peace Is With Us), 2005. Copyright © by Dario Campanile. Printed with permission from Dario Campanile.

100 Hearts, 2005. Copyright © by Andy Cao. Printed with permission from Andy Cao.

Naturally We, 2005. Copyright © by Squeak Carnwath. Printed with permission from Squeak Carnwath.

World Buddha Head Project, 2005. Copyright © by Long-Bin Chen. Printed with permission from Long-Bin Chen.

The Gates Project for Central Park, 1979—2005. Copyright © by Christo & Jeanne-Claude. Printed with permission from Christo & Jeanne-Claude.

Who Am I?, 2004. Copyright © by Costantino Ciervo. Printed with permission from Costantino Ciervo.

The Dalai Lama, 2005. Copyright © by Chuck Close. Printed with permission from Chuck Close.

Om Mani Padme Hum, 2005. Copyright © by Bernard Cosey. Printed with permission from Bernard Cosey.

Me and the Buddhists, 2005. Copyright © by Santiago Cucullu. Printed with permission from Santiago Cucullu.

Universal Happiness Project, 2005. Copyright © by Binh Danh. Printed with permission from Binh Danh.

Paranirvana, 1999. Copyright © by Lewis deSoto. Printed with permission from Lewis deSoto.

Possible Painting Impossible Sculpture No Ending Energy, 2004. Copyright © by Filippo diSambuy. Printed with permission from Filippo diSambuy.

The Ox, 2005. Copyright © by Doris Doerrie & Michael Wenger. Printed with permission from Doris Doerrie & Michael Wenger.

Symbol of Peace, 2004. Copyright © by Peig Fairbrook & Adele Fox. Printed with permission from Peig Fairbrook & Adele Fox.

Dharmakaya, 2004. Copyright © by Era & Donald Farnsworth. Printed with permission from Era & Donald Farnsworth.

Sun in an Empty Room, 2005. Copyright © by Spencer Finch. Printed with permission from Spencer Finch.

The Dalai Lama's Shoes, 2005. Copyright © by Sylvie Fleury. Printed with permission from Sylvie Fleury.

Om Mani Padme Hum, 2006. Copyright © by Louis Fox & Free Range Graphics. Printed with permission from Louis Fox & Free Range Graphics.

White Chrysalis, 2003. Copyright © by Adam Fuss. Printed with permission from Adam Fuss.

The Perfect Moment, 2006. Copyright © by Juan Galdeano. Printed with permission from Juan Galdeano.

Abu Ghraib, 2005. Copyright © by Rupert Garcia. Printed with permission from Rupert Garcia.

In the Moment, 2005. Copyright © by Robin Garthwait & Dan Griffin. Printed with permission from Robin Garthwait & Dan Griffin.

Neljorpa from Amdo, 1996. Copyright © by Richard Gere. Printed with permission from Richard Gere.

Tenzin Gyatso, Ocean of Wisdom, 2005. Copyright © by Losang Gyatso. Printed with permission from Losang Gyatso.

Tibet is the High Ground, 1991-2006. Copyright © by Helen Mayer Harrison & Newton Harrison. Printed with permission from Helen Mayer Harrison & Newton Harrison.

Impermanence: The Time of Man, 2005—2006. Copyright © by David & Hi-Jin Hodge. Printed with permission from David & Hi-Jin Hodge.

When In There Is Out There, 2005. Copyright © by Jim Hodges. Printed with permission from Jim Hodges.

IT IS IN YOUR SELF-INTEREST TO FIND A WAY TO BE VERY TENDER, 1983—1985. Copyright © by Jenny Holtzer. Printed with permission from Jenny Holtzer.

Head Series, 2002-2003. Copyright © by Tri Huu Luu. Printed with permission from Tri Huu Luu.

80 Liter Water Box, 2004. Copyright © by Ichi Ikeda. Printed with permission from Ichi Ikeda.

Untitled, 2006. Copyright © by Yoko Inoue. Printed with permission from Yoko Inoue.

The Poet, 2006. Copyright © by Ilya & Emilia Kabakov. Printed with permission from Ilya & Emilia Kabakov.

The Laughing Club, 2003. Copyright © by Jesal Kapadia. Printed with permission from Jesal Kapadia.

Untitled, 2002. Copyright © by Anish Kapoor. Printed with permission from Anish Kapoor.

A Needle Woman—Kitakyushu, Japan, 1999. Copyright © by Kimsooja. Printed with permission from Kimsooja.

Untitled, 2005—2006. Copyright © by Enrique Martínez Celaya. Printed with permission from Enrique Martínez Celaya.

Dreamstorming, 1998. Copyright © by Nefeli Massia. Printed with permission from Nefeli Massia.

Avalokiteshvara (Chenrezig), 2005. Copyright © by Yumyo Miyasaka. Printed with permission from Yumyo Miyasaka.

Regarde, 2005. Copyright © by Gabriela Morawetz. Printed with permission from Gabriela Morawetz.

Sanmon WCC – yupotanjyu + nupotanje, 2005. Copyright © by Kisho Mukaiyama. Printed with permission from Kisho Mukaiyama.

In His Ultimate Compassion, His Holiness the 14th Dalai Lama Manifests Himself, 2005. Copyright © by Tom Nakashima. Printed with permission from Tom Nakashima.

Untitled, 2006. Copyright © by Yoshiro Negishi. Printed with permission from Yoshiro Negishi.

Penan Leader Confronts Logging Truck, 2002. Copyright © by Dang Ngo. Printed with permission from Dang Ngo.

Harp and Lyre, 2004. Copyright © by Michele Oka Doner. Printed with permission from Michele Oka Doner.

The Scribe, 2005. Copyright © by Robert & Shana Parke-Harrison. Printed with permission from Robert & Shana Parke-Harrison.

Luz y Solidaridad (Light and Solidarity), 2006. Copyright © by Susan Plum. Printed with permission from Susan Plum.

Reclamation, 2006. Copyright © by Rosemary Rawcliffe. Printed with permission from Rosemary Rawcliffe.

Brief History of Tibet, 2003; A Man Following a Tail, 2003. Copyright © by Tenzing Rigdol. Printed with permission from Tenzing Rigdol.

Spiral-Link, 2004. Copyright © by Michal Rovner. Printed with permission from Michal Rovner.

Sound Mandala, 2006. Copyright © by Ryuchi Sakamoto. Printed with permission from Ryuchi Sakamoto.

The Vietnamese Migration: the Beach of Vung Tau, 1995. Copyright © by Sebastiao Salgado. Printed with permission from Sebastiao Salgado.

Reincarnation, 2005. Copyright © by Salustiano. Printed with permission from Salustiano.

Bamiyan: A Continuum, 2001. Copyright © by Andra Samelson. Printed with permission from Andra Samelson.

Out of the Blue, 2004—2005. Copyright © by Arlene Shechet. Printed with permission from Arlene Shechet.

Who Leads Who Follows, 2004. Copyright © by Jaune Quick-to-See Smith. Printed with permission from Jaune Quick-to-See Smith.

Sno6_34 (from the series alleverythingthatisyou), 2006. Copyright © by Mike & Doug Starn. Printed with permission from Mike & Doug Starn.

Blue, 2005. Copyright © by Pat Steir. Printed with permission from Pat Steir.

Passage #2, 1998. Copyright © by Hoang Van Bui. Printed with permission from Hoang Van Bui.

Andar Com Fé, 2000. Copyright © by Adriana Varejao. Printed with permission from Adriana Varejao.

H.H. Dalai Lama: A Blessing, 2005, Bodies of Light, 2006. Copyright © by Bill Viola. Printed with permission from Bill Viola.

Temple at night, 2004. Coyright © by Inkie Whang. Printed with permission from Inkie Whang.

Serpent Frightened by Color, Abstraction and Time, 2004. Copyright © by William Wiley. Printed with permission from William Wiley.

Terminus, 2005—2006. Copyright © by Katarina Wong. Printed with permission from Katarina Wong.

Web/Transient #2, 2005. Copyright © by Yuriko Yamaguchi. Printed with permission from Yuriko Yamaguchi.

Colophon

the missing peace curriculum

The Missing Peace isn't a traditional art exhibition. It has an explicitly moral and educational purpose, to promote serious engagement, on the individual and collective level, on the part of youth and lifelong learners, in the essential questions of values, ethics and peace.

As part of *The Missing Peace Project* we have created a suite of educational materials for all age ranges. These materials are freely available for downloading from the Dalai Lama Foundation website.

Appreciation is due to Marsha Clark, Steve Rowley, Jim Schuyler, and Randy Taran of the Dalai Lama Foundation Curriculum Advisory Board, to the dedicated and professional group from Planners Collaborative, and to Chade-Meng Tan.

We will continue to develop *The Missing Peace Curriculum* as the exhibition continues its journey in the years to come. Our wish is that these materials be taken up, used, adapted and built upon by educators in classrooms and study circles all over the world.

Tony Hoeber
Executive Director
The Dalai Lama Foundation

The titles in the book were typeset in is Democratica, created by Miles Newlyn in 1991. Main body text was typeset in Adobe Jenson Pro, which was designed by Robert Slimbach of the Adobe type design team. Slimbach based it on Nicolas Jenson's roman and Ludovico degli Arrighi's italic typeface designs. This book was printed in five colors (process color plus a metallic gold) with an offline spot-gloss varnish.

Publisher & Creative Director: *Raoul Goff*

Executive Directors: *Michael Madden & Peter Beren*

Acquisitions Editor: *Lisa Fitzpatrick*

Art Director: *Iain R. Morris*

Designer: *Andrew Ogus*

Project Editor: *Emilia Thiuri*

Managing Editors: *Catherine Butler & Pamela Holm*

Production Manager: *Lisa Bartlett*

Studio Production: *Noah Potkin*

EarthAware Editions would like to thank Carina Cha, Kath Delaney, Noa Jones, Nam Nguyen, Colin Whitlow, and Judy Zimola.